SONY ALPHA A7 IV USER GUIDE

The Ultimate Handbook for Mastering the Lens and Using Your Digital Camera

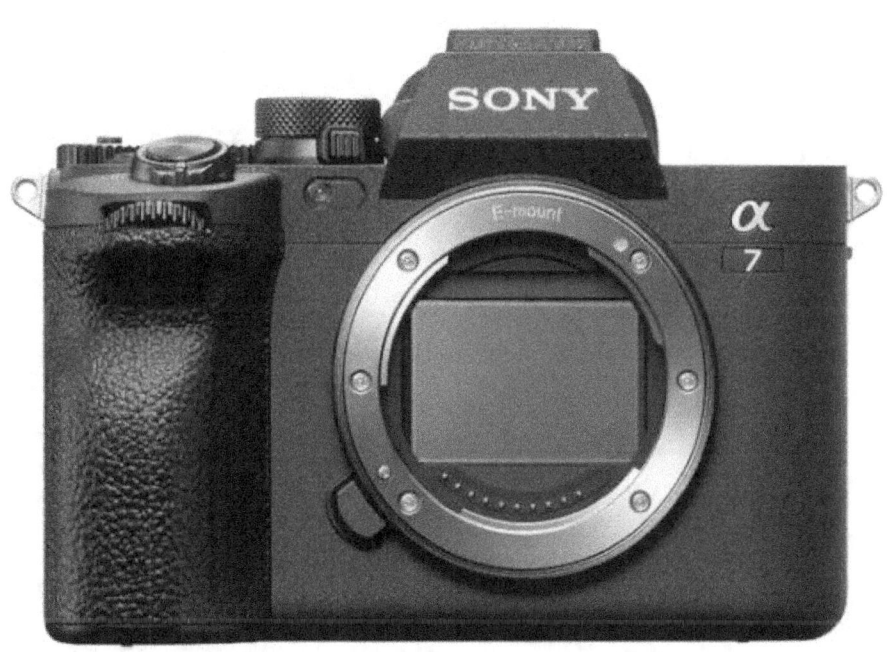

FRANCISCO T. WOODS

Copyright © 2024 Francisco T. Woods
All rights reserved

No part of this publication may be reproduced, distributed, or transmitted in any form or by any means, including photocopying, recording, or other electronic or mechanical methods, without the prior written permission of the publisher, except in the case of brief quotations embodied in critical reviews and certain other non-commercial uses permitted by copyright law

TABLE OF CONTENTS

- DISCLAIMER .. 6
- CHAPTER ONE .. 8
 - INTRODUCTION .. 8
 - Overview of Sony Alpha a7 IV 8
 - Features and Capabilities ... 10
- CHAPTER TWO ... 18
 - GETTING STARTED WITH YOUR CAMERA 18
 - Unboxing the Camera .. 18
 - Charging and Inserting the Battery 20
 - Mounting a Lens .. 22
 - Inserting a Memory Card ... 25
 - Initial Setup and Configuration 28
- CHAPTER THREE .. 34
 - CAMERA BASICS .. 34
 - Understanding the Controls and Buttons 34
 - Using the Touchscreen .. 41
 - Menu Navigation ... 44
- CHAPTER FOUR .. 48
 - SHOOTING MODES .. 48
 - Shooting Modes .. 48
- CHAPTER FIVE ... 54
 - LENSES AND ACCESSORIES 54
 - Choosing the Right Lenses for Your Needs 54

Essential Camera Accessories .. 61
CHAPTER SIX .. 68
 AUTOFOCUS MASTERY ... 68
 Understanding Autofocus Systems .. 68
 Customizing Focus Settings ... 70
CHAPTER SEVEN ... 78
 EXPOSURE CONTROL ... 78
 Understanding Exposure Triangle: Aperture, Shutter Speed, ISO
.. 78
 Manual vs. Automatic Exposure Modes .. 81
 Exposure Compensation .. 84
CHAPTER EIGHT .. 88
 IMAGE QUALITY SETTINGS ... 88
 Selecting Image File Formats: RAW vs. JPEG 88
 Adjusting Picture Profiles and Creative Looks 92
 Using White Balance Settings .. 95
CHAPTER NINE ... 98
 VIDEO RECORDING .. 98
 Frame Rates and Resolutions ... 98
 Using S-Log3 and HLG for Professional Video 100
 Audio Recording Options .. 103
CHAPTER TEN ... 106
 ADVANCED SHOOTING TECHNIQUES .. 106
 Low Light Photography ... 106
 High-Speed Photography ... 108

 Time-Lapse and Interval Shooting .. 109
 Panorama and HDR Imaging ..112
CHAPTER ELEVEN ...116
 CONNECTIVITY ...116
CHAPTER TWELVE ... 120
 EDITING AND POST-PROCESSING 120
 Basic Editing Workflow .. 120
 Using Sony's Image Editing Software 123
 Post-Processing RAW Files .. 126
CHAPTER THIRTEEN .. 130
 MAINTENANCE AND TROUBLESHOOTING 130
 Care and Maintenance ... 130
 Troubleshooting Common Issues ... 132
 Resources .. 137
CHAPTER FOURTEEN ... 140
 APPENDICES ... 140
 Technical Specifications ... 140
 Glossary of Terms ... 142

DISCLAIMER

The contents of this book are provided for informational and entertainment purposes only. The author and publisher make no representations or warranties with respect to the accuracy, applicability, completeness, or suitability of the contents of this book for any purpose.

The information contained within this book is based on the author's personal experiences, research, and opinions, and it is not intended to substitute for professional advice. Readers are encouraged to consult appropriate professionals in the field regarding their individual situations and circumstances.

The author and publisher shall not be liable for any loss, injury, or damage allegedly arising from any information or suggestions contained within this book. Any reliance you place on such information is strictly at your own risk.

Furthermore, the inclusion of any third-party resources, websites, or references does not imply endorsement or responsibility for the content or services provided by these entities.

Readers are encouraged to use their own discretion and judgment in applying any information or recommendations contained within this book to their own lives and situations.

All rights reserved. No part of this book may be reproduced, distributed, or transmitted in any form or by any means, including photocopying, recording, or other electronic or mechanical methods, without the prior written permission of the publisher, except in the case of brief quotations embodied in critical reviews and certain other non-commercial uses permitted by copyright law.

Thank you for reading and understanding this disclaimer

CHAPTER ONE
INTRODUCTION

Overview of Sony Alpha a7 IV

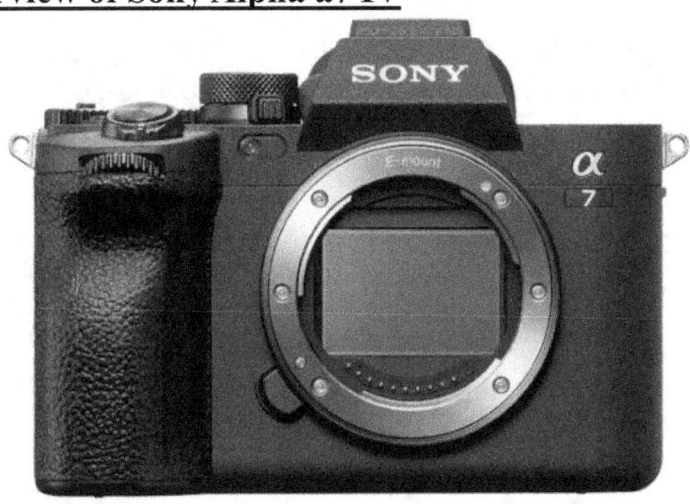

The Sony a7 IV builds upon the success of the a7 III, offering significant upgrades in image quality, video features, and overall performance. Released in late 2021, this full-frame mirrorless camera boasts a powerful 33-megapixel sensor for stunning detail and a fast BIONZ XR processor for improved speed and image processing.

Focusing is a breeze with the a7 IV's advanced 759-point autofocus system, featuring real-time Eye AF and tracking for both people and animals. Capture fast-paced moments with ease using the 10 fps continuous shooting mode.

For videographers, the a7 IV shines. It can record high-quality 4K video at up to 60 fps with 10-bit color for professional results. S-Cinetone and S-Log3 features allow for achieving a cinematic look and greater flexibility in editing.

The a7 IV is also designed for comfort and convenience. The 3-inch vari-angle touchscreen lets you compose shots from various angles, while the high-resolution viewfinder provides a clear view of the scene. The camera's durable build and weather sealing make it suitable for various shooting conditions.

For storage and sharing, the a7 IV offers dual memory card slots and built-in Wi-Fi and Bluetooth connectivity. The long-lasting battery life ensures you can stay focused on capturing your creative vision.

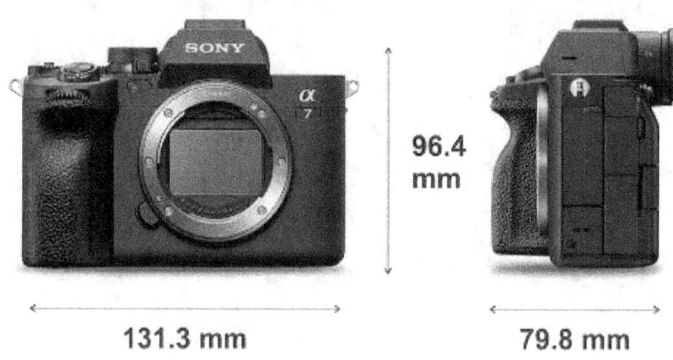

The Sony a7 IV is a well-rounded camera that caters to both photo and video enthusiasts. It delivers exceptional image quality, advanced features, and a user-friendly design, making it a compelling choice for those looking to take their creative work to the next level.

Features and Capabilities

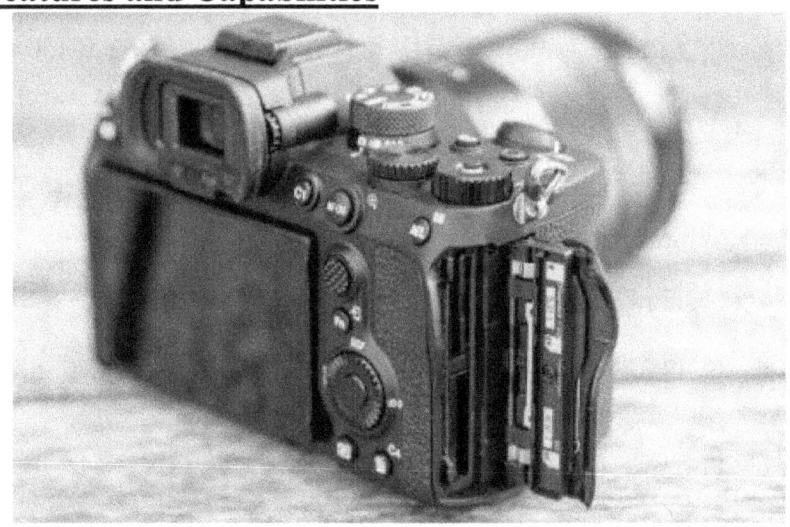

Body Type:

- Type: SLR-style mirrorless

Sensor:

- Maximum Resolution: 7008 x 4672
- Aspect Ratios: 1:1, 4:3, 3:2, 16:9
- Effective Pixels: 33 megapixels
- Total Pixels: 34 megapixels
- Size: Full frame (35.6 x 23.8 mm)
- Type: BSI-CMOS
- Processor: Bionz XR

Image:

- ISO Range: Auto, 100-51200 (expandable to 50-204800)
- Minimum Boosted ISO: 50
- Maximum Boosted ISO: 204800
- White Balance Presets: 7
- Custom White Balance: Yes
- Image Stabilization: Sensor-shift, 5-axis, CIPA rated at 5.5 stops
- Formats: Uncompressed RAW
- JPEG Quality: Extra fine, fine, normal

Optics & Focus:

- Autofocus:
 - Contrast Detect (sensor)
 - Phase Detect
 - Multi-area
 - Center
 - Selective single-point
 - Tracking
 - Single
 - Continuous
 - Touch
 - Face Detection

- Live View
- Manual Focus: Yes
- Focus Points: 759
- Lens Mount: Sony E
- Focal Length Multiplier: 1×

Screen / Viewfinder:

- LCD: Fully articulated, 3 inches, 1,036,800 dots, touch screen, TFT LCD
- Viewfinder: Electronic, 100% coverage, 0.78× magnification, 3,686,400 resolution

Photography Features:

- Shutter Speed: 30 sec to 1/8000 sec
- Exposure Modes: Aperture priority, Shutter priority, Manual exposure
- Flash: External only (Multi-interface shoe)
- Continuous Drive: 10 fps
- Self-timer: Yes
- Metering Modes: Multi, Center-weighted, Highlight-weighted, Average, Spot
- Exposure Compensation: ±5 (in 1/3 EV, 1/2 EV steps)
- AE Bracketing: ±5 (3, 5 frames at 1/3 EV, 1/2 EV, 2/3 EV, 1 EV steps)
- WB Bracketing: Yes

Videography Features:

- Formats: MPEG-4, XAVC S, XAVC HS, XAVC S-I, H.264, H.265
- Modes:
 - 3840 x 2160 @ 60p / 200 Mbps (XAVC HS, MP4, H.265, Linear PCM)
 - 3840 x 2160 @ 50p / 200 Mbps (XAVC HS, MP4, H.265, Linear PCM)
 - 3840 x 2160 @ 30p / 140 Mbps (XAVC HS, MP4, H.265, Linear PCM)
 - 3840 x 2160 @ 25p / 140 Mbps (XAVC HS, MP4, H.265, Linear PCM)
 - 3840 x 2160 @ 24p / 100 Mbps (XAVC HS, MP4, H.265, Linear PCM)
 - 3840 x 2160 @ 60p / 600 Mbps (XAVC S-I, MP4, H.264, Linear PCM)
 - 3840 x 2160 @ 50p / 500 Mbps (XAVC S-I, MP4, H.264, Linear PCM)
 - 3840 x 2160 @ 30p / 300 Mbps (XAVC S-I, MP4, H.264, Linear PCM)
 - 3840 x 2160 @ 25p / 250 Mbps (XAVC S-I, MP4, H.264, Linear PCM)
 - 3840 x 2160 @ 24p / 240 Mbps (XAVC S-I, MP4, H.264, Linear PCM)
 - 3840 x 2160 @ 60p / 200 Mbps (XAVC S, MP4, H.264, Linear PCM)

- 3840 x 2160 @ 50p / 200 Mbps (XAVC S, MP4, H.264, Linear PCM)
- 3840 x 2160 @ 30p / 140 Mbps (XAVC S, MP4, H.264, Linear PCM)
- 3840 x 2160 @ 25p / 140 Mbps (XAVC S, MP4, H.264, Linear PCM)
- 3840 x 2160 @ 24p / 100 Mbps (XAVC S, MP4, H.264, Linear PCM)
- 1920 x 1080 @ 60p / 222 Mbps (XAVC S-I, MP4, H.264, Linear PCM)
- 1920 x 1080 @ 50p / 185 Mbps (XAVC S-I, MP4, H.264, Linear PCM)
- 1920 x 1080 @ 30p / 111 Mbps (XAVC S-I, MP4, H.264, Linear PCM)
- 1920 x 1080 @ 25p / 93 Mbps (XAVC S-I, MP4, H.264, Linear PCM)
- 1920 x 1080 @ 24p / 89 Mbps (XAVC S-I, MP4, H.264, Linear PCM)
- 1920 x 1080 @ 120p / 100 Mbps (XAVC S, MP4, H.264, Linear PCM)
- 1920 x 1080 @ 100p / 100 Mbps (XAVC S, MP4, H.264, Linear PCM)
- 1920 x 1080 @ 60p / 50 Mbps (XAVC S, MP4, H.264, Linear PCM)
- 1920 x 1080 @ 50p / 50 Mbps (XAVC S, MP4, H.264, Linear PCM)

- 1920 x 1080 @ 25p / 50 Mbps (XAVC S, MP4, H.264, Linear PCM)
- 1920 x 1080 @ 24p / 50 Mbps (XAVC S, MP4, H.264, Linear PCM)

- Microphone: Stereo
- Speaker: Mono

Storage:

- Types: One CFexpress Type A/UHS-II SD, One UHS-II SD

Connectivity:

- USB: USB 3.2 Gen 2 (10 GBit/sec), USB charging (USB PD supported)
- HDMI: Yes (Standard)
- Microphone Port: Yes
- Headphone Port: Yes
- Wireless: Built-in (802.11ac dual band + Bluetooth)
- Remote Control: Yes (wireless or smartphone)

Physical:

- Sealed: Yes (environmentally sealed)
- Battery: NP-FZ100 lithium-ion battery
- Battery Life (CIPA): 580 shots
- Weight (with battery): 659 g (1.45 lb / 23.25 oz)
- Dimensions: 131 x 96 x 80 mm (5.16 x 3.78 x 3.15″)

Other Features:

- Orientation Sensor: Yes
- GPS: None

CHAPTER TWO
GETTING STARTED WITH YOUR CAMERA

Unboxing the Camera

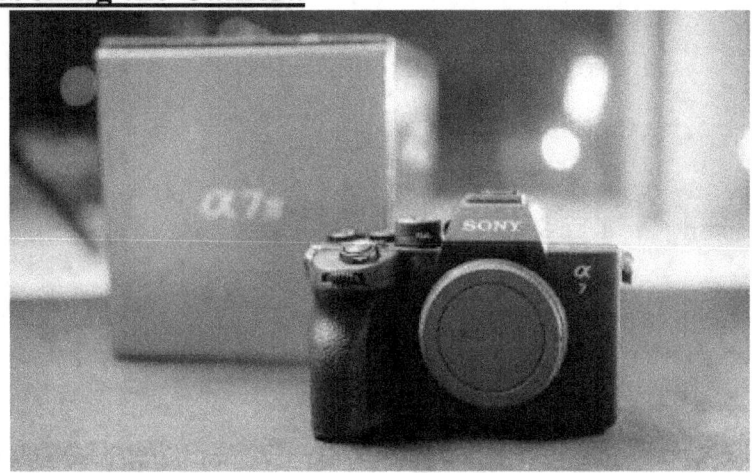

Unboxing the Sony Alpha a7 IV is an exciting experience for photography enthusiasts and professionals. Here's a step-by-step guide on what to expect and how to proceed:

Outer Packaging:

- The camera comes in a sturdy, well-branded box with images and key specifications printed on it.

Opening the Box:

- Open the box from the top. On top, you'll typically find the user manuals, warranty card, and other documentation.

First Layer:

- Remove the top layer of documentation. Below it, there's a layer of protective foam.

Camera Body:

- Lift the foam to reveal the camera body. The Sony Alpha a7 IV is usually wrapped in a soft protective cover or bubble wrap. Carefully take out the camera body and set it aside.

Accessories Compartment:

Adjacent to the camera body, there is a separate compartment containing the accessories. These typically include:

- Battery: The NP-FZ100 lithium-ion battery.

- Battery Charger: For charging the battery outside the camera.

- USB Cable: USB 3.2 Gen 2 cable for data transfer and charging.

- Power Adapter: For charging via the USB cable.

- Shoulder Strap: A branded Sony shoulder strap for carrying the camera.

- Eyepiece Cup: Usually attached to the camera, but sometimes packed separately.

- Hot Shoe Cover: Protects the hot shoe mount when not in use.

Lenses (if included):

- If you purchased a kit that includes a lens, it will be in a separate compartment, wrapped in protective material.

Inspecting the Camera:

Carefully unwrap the camera body. Check for any visible damage and ensure that all buttons and dials are intact and functional.

Unboxing the Sony Alpha a7 IV is straightforward. Handle all components with care and verify that all items listed in the manual are present. Once unboxed, charge the battery fully before using the camera to ensure optimal performance.

Charging and Inserting the Battery

Unbox the Battery and Charger:

- Take the NP-FZ100 lithium-ion battery and the charger out of the accessories compartment.

Prepare the Charger:

- Connect the power adapter to the battery charger.
- Plug the power adapter into an electrical outlet.

Insert the Battery into the Charger:

- Align the battery contacts with the charger and insert the battery securely.

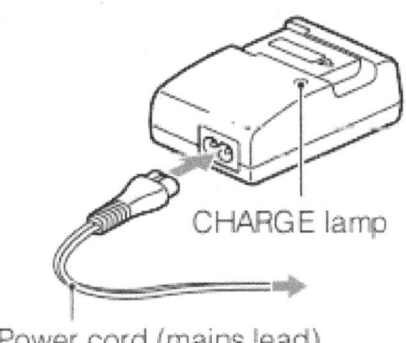

Charging Status:

- The charging indicator light on the charger will illuminate. It will stay lit while charging and turn off when the battery is fully charged.

- Charging a completely depleted battery usually takes a few hours. Check the user manual for specific charging times.

Inserting the Battery into the Camera

Locate the Battery Compartment:

- The battery compartment is at the bottom of the camera.

Open the Battery Compartment:

- Slide the battery compartment lock to open the battery door.

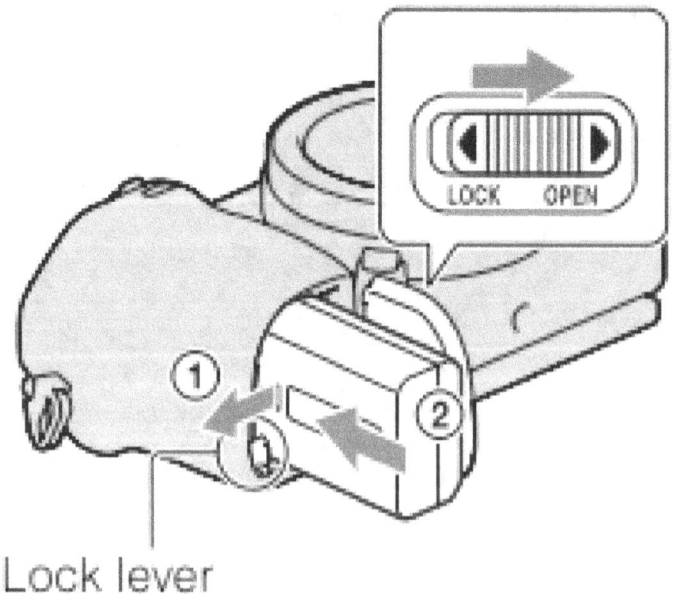

Insert the Battery:

- Align the battery contacts with the camera contacts inside the compartment.
- Insert the battery, ensuring it clicks into place securely.

Close the Battery Compartment:

- Close the battery door and slide the lock to secure it.

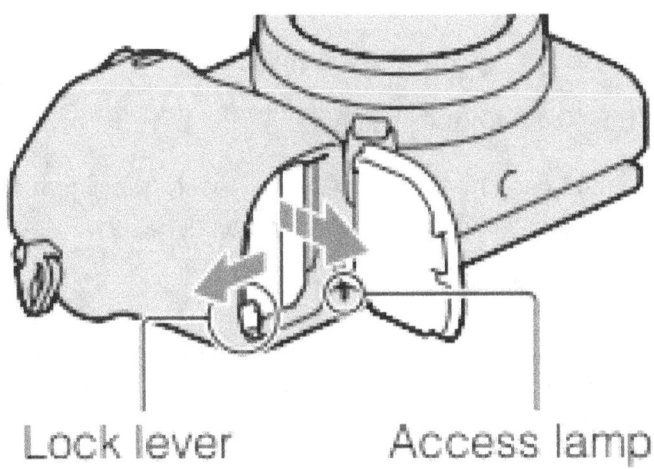

Ensure the battery is fully charged before inserting it into the camera. Proper alignment of the battery contacts is essential for a secure fit.

Mounting a Lens

Mounting a lens on the camera is essential for preparing your camera to capture photos and videos. Here's a detailed guide on how to do it correctly:

Preparing the Lens and Camera:

Gather Your Equipment:

- Make sure you have your Sony Alpha a7 IV camera and a compatible Sony E-mount lens.

Clean the Lens and Camera Mount:

- Use a soft, dry cloth to gently wipe the lens and camera mount to remove any dust or dirt.

Removing the Body Cap and Rear Lens Cap:

Remove the Body Cap from the Camera:

- Hold the camera securely and twist the body cap counterclockwise to remove it. Set it aside safely.

Remove the Rear Lens Cap:

- Hold the lens securely and twist the rear lens cap counterclockwise to remove it. Place it aside with the body cap.

Mounting the Lens:

Align the Mounting Marks:

- Locate the white or red mounting index on the lens and the corresponding mark on the camera mount.

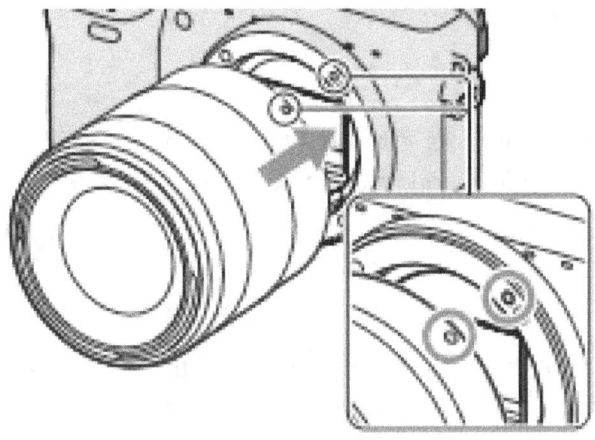

Attach the Lens to the Camera:

- Align the marks and gently insert the lens into the camera mount.

Rotate the Lens to Lock:

- Rotate the lens clockwise until you hear a click, indicating the lens is securely locked into place.

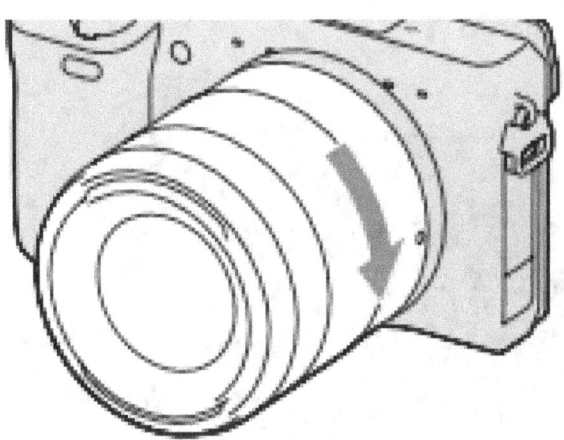

Verifying the Connection:

Check the Fit:

- Ensure the lens is firmly attached and there is no gap between the lens and the camera body.

Test the Functionality:

- Power on the camera and check if the lens is correctly recognized. Ensure autofocus and other features are functioning properly.

Ensure both the lens and camera mount are clean before starting the process. Properly mounting the lens ensures optimal performance and protection for both the camera and lens.

Inserting a Memory Card

Properly inserting a memory card is essential for storing your photos and videos. Follow these steps to correctly insert a memory card into your Sony Alpha a7 IV:

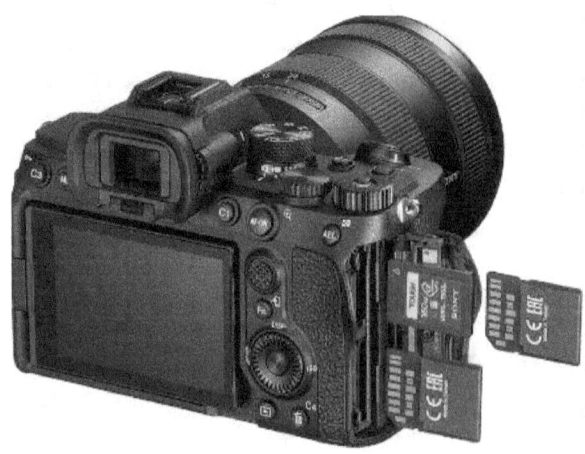

Preparing the Memory Card:

Choose the Right Memory Card:

- The Sony Alpha a7 IV supports CFexpress Type A and UHS-II SD memory cards. Make sure you have a compatible card.

Check the Memory Card:

- Ensure the memory card is clean and free from dust and damage.

Opening the Memory Card Slot:

Locate the Memory Card Slot:

- The memory card slot is located on the side of the camera.

Open the Memory Card Slot Cover:

- Slide the cover in the indicated direction to open it.

Inserting the Memory Card:

Insert the Memory Card:

- Align the memory card with the slot. For CFexpress Type A cards, use the CFexpress slot. For SD cards, use the SD slot.

- Insert the card gently until it clicks into place, ensuring the label is facing the correct direction as indicated near the slot.

Close the Memory Card Slot Cover:

- Slide the cover back until it clicks and is securely shut.

Verifying the Memory Card:

Power On the Camera:

- Turn on the camera using the power switch.

Check the Memory Card Recognition:

- Look at the screen to ensure the memory card is recognized. The camera will display the available storage space and indicate that the card is ready for use.

Formatting the Memory Card (Optional but Recommended)

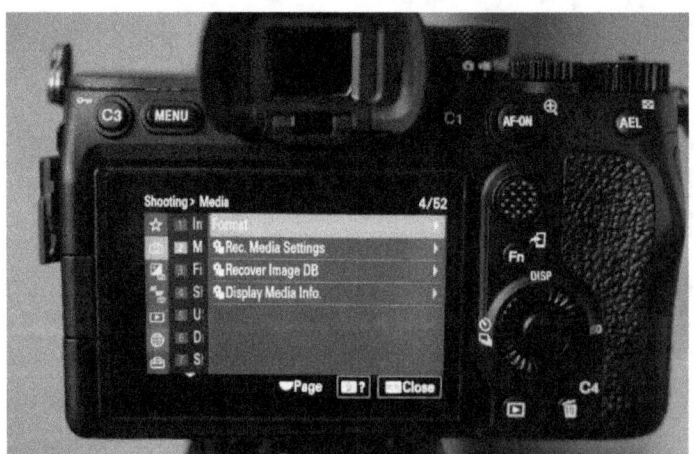

Access the Menu:

- Press the menu button to access the camera's menu.

Navigate to the Menu:

- Use the navigation buttons or touchscreen to go to the Setup Menu and find 'Shooting.'

Select 'Format':

- Choose the 'Format' option and follow the on-screen instructions to format the memory card. Formatting ensures the card is properly configured for use with your camera.

Power on the camera to ensure the card is recognized. Optionally, format the memory card to prepare it for use. This process ensures your camera is ready to store high-quality photos and videos.

Initial Setup and Configuration

Setting up your Sony Alpha a7 IV for the first time involves configuring various settings to optimize its performance and customize it to your preferences. Follow these steps to complete the initial setup and configuration:

Power On the Camera:

Turn on the camera using the power switch located near the shutter button.

Setting Up the Language, Date, and Time:

Select Language:

- When the camera powers on for the first time, it will prompt you to select your preferred language. Use the control wheel or touchscreen to navigate and select your language.

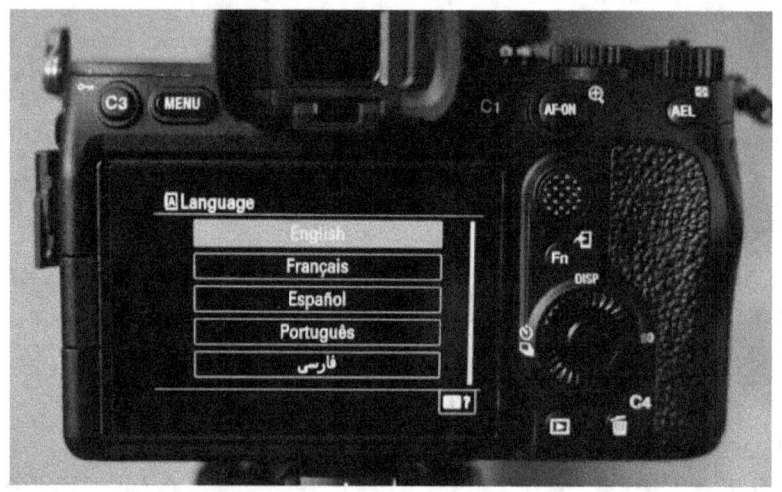

Set Date and Time:

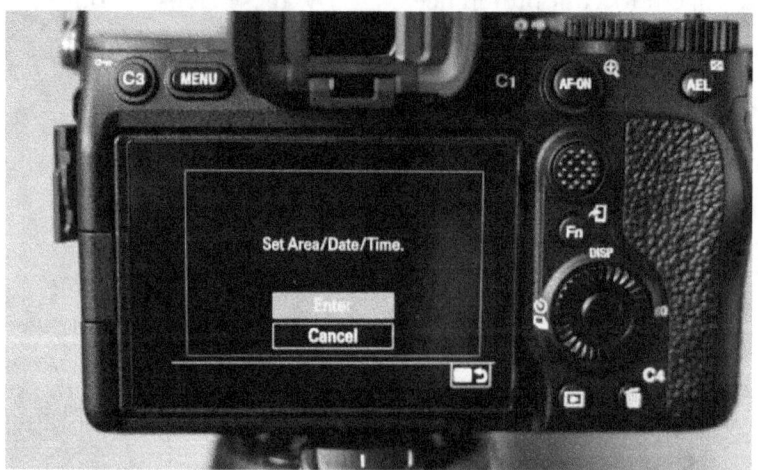

- Follow the on-screen instructions to set the current date and time. This ensures accurate timestamping of your photos and videos.

Configuring Basic Settings:

Set the Area/Region:

- Select your geographical area or region to ensure accurate date and time settings.

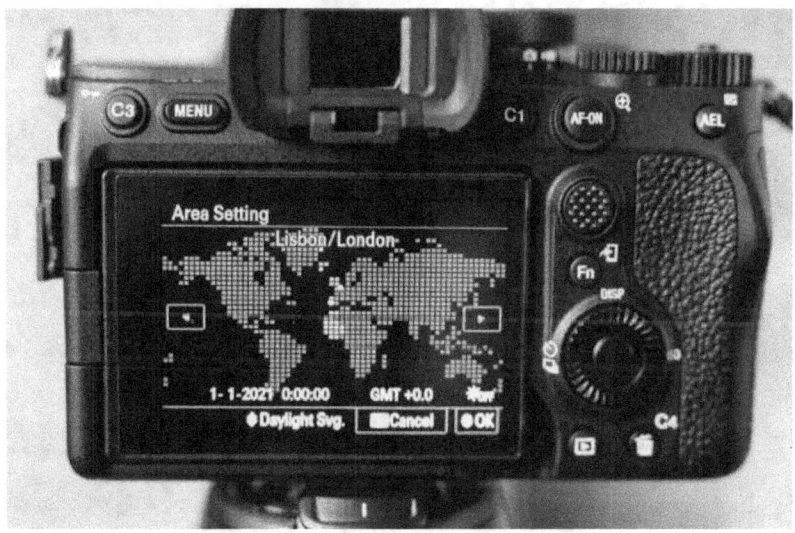

Adjust Display Settings:

- Go to the "Setup" menu and adjust the display settings to your preference, including brightness and color.

Select Image Quality:

- In the "Shoot Mode/Drive" menu, choose your preferred image quality settings (e.g., RAW, JPEG, or both).

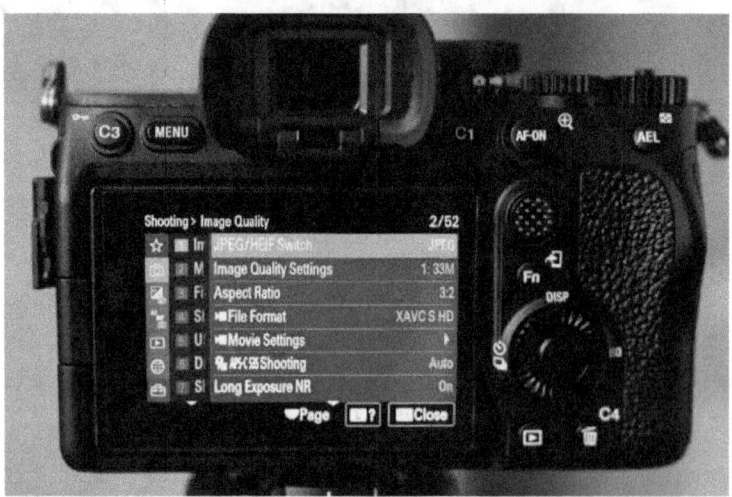

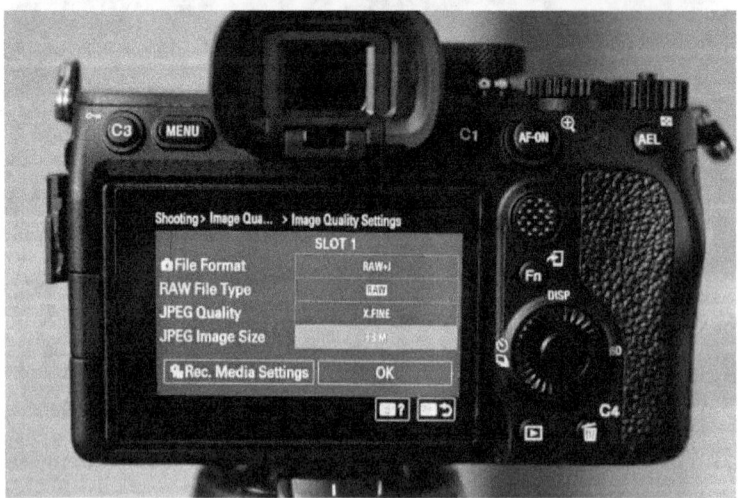

Customizing Camera Functions:

Set Up Custom Buttons:

- Navigate to the "Custom Key" settings in the menu to assign frequently used functions to the customizable buttons on the camera.

Configure Autofocus Settings:

- Adjust the autofocus settings in the "AF/MF" menu to suit your shooting style, including AF modes and focus area selection.

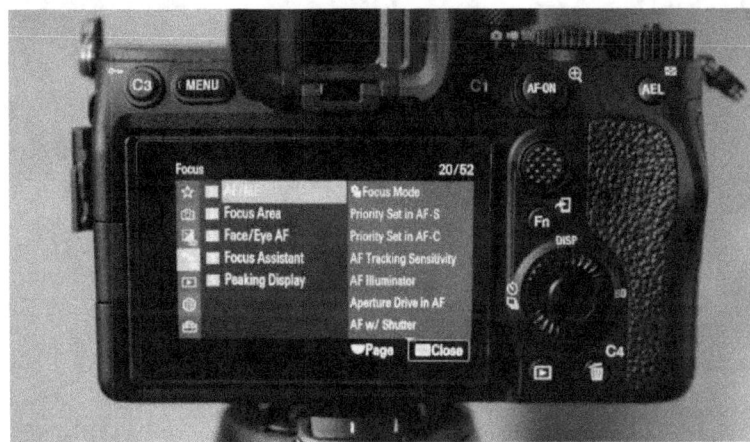

Enable Image Stabilization:

- Ensure the 5-axis image stabilization is enabled in the "SteadyShot" settings for sharper images, especially in low-light conditions.

Connecting to Devices:

Set Up Wi-Fi and Bluetooth:

- Go to the "Network" menu to connect the camera to your Wi-Fi network and pair it with your smartphone via Bluetooth for easy photo sharing and remote control.

Register a Smartphone:

- Use the "Smartphone" setting to register your phone for remote shooting and image transfer using the Sony Imaging Edge Mobile app.

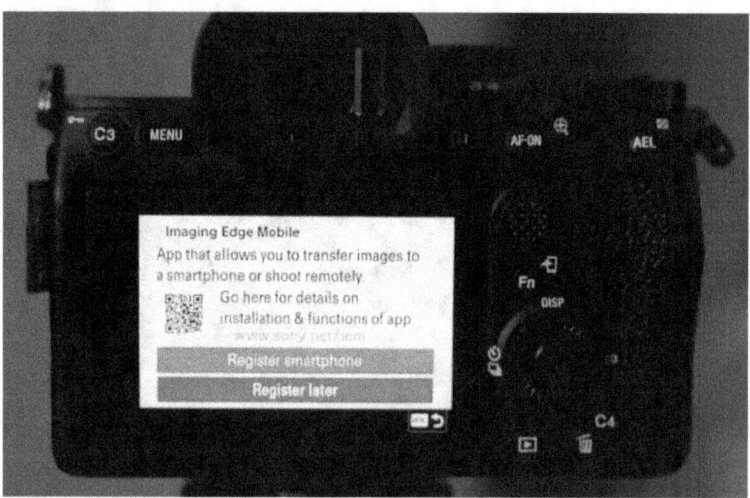

Final Adjustments:

Set Up Power Save Options:

- Configure the power save settings to extend battery life when the camera is not in use.

Check Firmware Updates:

Ensure your camera firmware is up-to-date by checking for updates on Sony's official website and following the instructions to install any available updates.

CHAPTER THREE
CAMERA BASICS

Understanding the Controls and Buttons

Understanding the controls and buttons on the Sony Alpha a7 IV is key to using it effectively. Here's a detailed guide to the main components and their functions:

Top Controls:

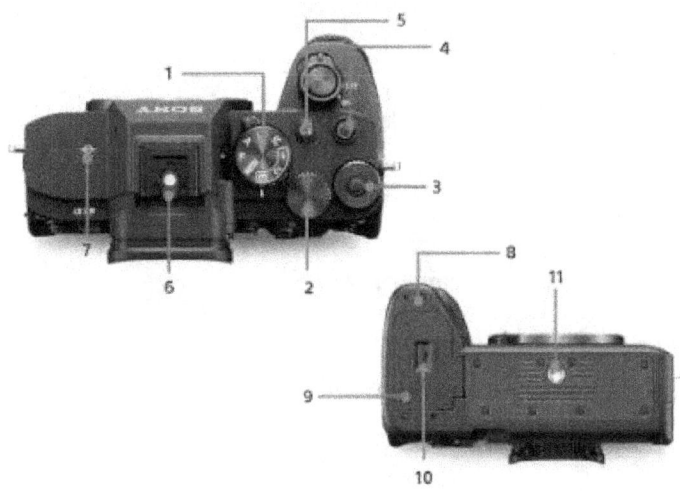

Mode Dial:

- Location: Top-left side of the camera.

- Function: Switches between different shooting modes, including:

 - Auto: Automatic selection of the best settings.

 - Program (P): Camera selects aperture and shutter speed; you control other settings.

- Aperture Priority (A): You choose the aperture; the camera adjusts the shutter speed.
- Shutter Priority (S): You choose the shutter speed; the camera adjusts the aperture.
- Manual (M): Full control over both aperture and shutter speed.
- Custom Modes (1, 2): Preset modes that you can customize.

Control Dial:

- Location: Near the shutter button.
- Function: Adjusts settings like aperture, shutter speed, and exposure compensation, depending on the mode.

Shutter Button:

- Location: On the camera grip.
- Function: Press halfway to focus; press fully to take a picture.

C2 Button:

- Location: Near the shutter button.
- Function: Customizable buttons for quick access to frequently used function.

Exposure Compensation Dial:

- Location: To the right of the mode dial.
- Function: Adjusts exposure compensation to brighten or darken images.

Rear Controls:

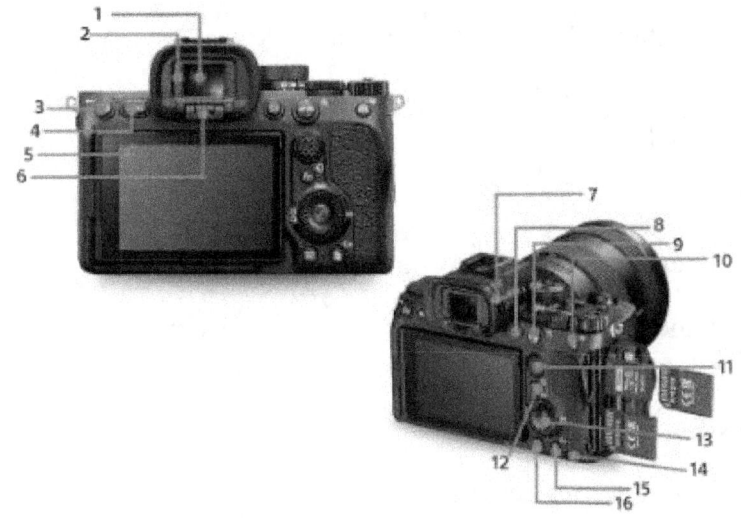

Menu Button:

- Location: Top-left side of the rear panel.
- Function: Opens the main menu for accessing and changing settings.

C3 Button:

- Location: Near the menu button.
- Function: Customizable buttons for quick access to frequently used function.

Function (Fn) Button:

- Location: Above the multi-selector button.

- Function: Provides quick access to a customizable function menu for frequently used settings.

Multi-Selector (Control Wheel):

- Location: Middle of the rear panel.
- Function: Navigates through menus and settings; also works as a directional pad and confirms selections.

AEL Button:

- Location: Near the top-right corner.
- Function: Locks exposure to allow recomposing without changing exposure settings.

AF-ON Button:

- Location: Beside AEL button.
- Function: Activates autofocus; useful for back-button focusing. Locks exposure to allow recomposing without changing exposure settings.

C1 Button:

- Location: Near the AF-ON button.
- Function: Customizable buttons for quick access to frequently used function.

Playback Button:

- Location: Below the Multi-Selector.
- Function: Lets you review photos and videos on the LCD screen.

Delete Button:

- Location: To the right of the Playback button.
- Function: Deletes unwanted photos and videos.

Joystick:

- Location: Below the AF-ON button.
- Function: Moves the focus point and navigates through menus.

Front Controls:

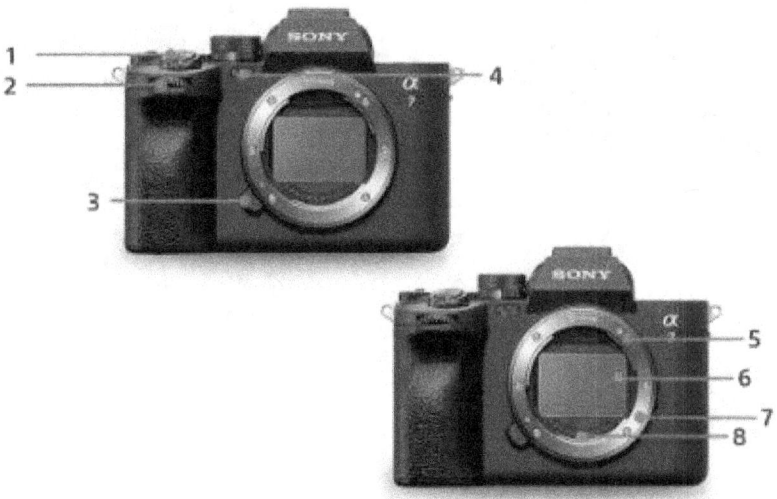

Lens Release Button:

- Location: Near the lens mount on the front.
- Function: Press to detach the lens from the camera body.

Focus Mode Selector:

- Location: On the front side.

- Function: Toggles between autofocus (AF) and manual focus (MF) modes.

Side Controls:

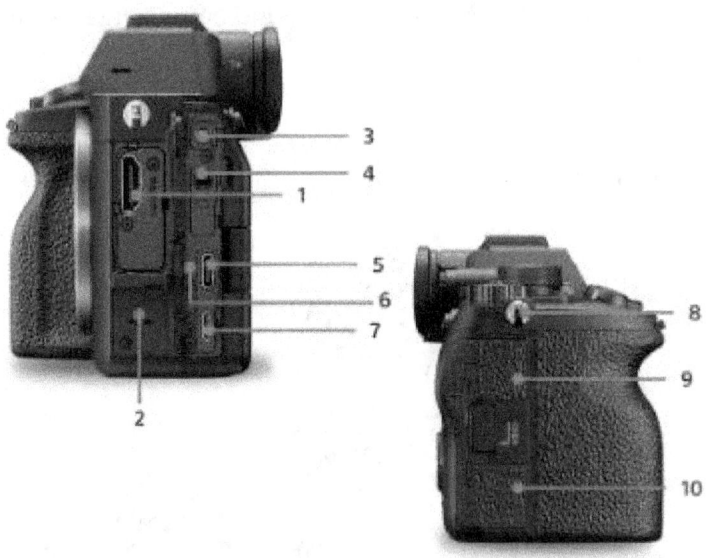

Memory Card Slot Cover:

- Location: On the side.

- Function: Slide to access the memory card slots; supports both CFexpress Type A and UHS-II SD cards.

Microphone and Headphone Ports:

- Location: On the side panel.

- Function: Connect external microphones for better audio and headphones for monitoring.

USB and HDMI Ports:

- Location: On the side panel.
- Function: For charging, data transfer, and connecting to external displays.

Remote Control Port:

- Location: On the side panel.
- Function: Connect an external remote control.

Multi Interface Shoe:

- Location: Top of the camera.
- Function: Attach compatible accessories like external flashes, microphones, and viewfinders.

Bottom:

- Tripod Mount: This is a threaded metal socket located in the center of the bottom of the camera body. It allows you to securely attach the camera to a tripod for stable shooting. This is particularly helpful for long exposures, HDR photography, videography, or situations where you need to minimize camera shake. The standard tripod screw size is typically 1/4"-20 UNC.
- Battery Compartment Door: This compartment, usually located towards the front of the bottom of the camera, houses the camera's rechargeable lithium-ion battery (model NP-FZ100). A small lever on the side of the compartment allows you to release and remove the battery for charging or replacement.

Knowing the controls and buttons on the Sony Alpha a7 IV is crucial for efficient operation. Familiarize yourself with the top, rear, front,

and side controls to maximize your camera's capabilities. This understanding will help you navigate settings quickly and capture high-quality photos and videos with ease.

Using the Touchscreen

The touchscreen on the camera provides intuitive control for menu navigation, setting adjustments, and focus management. Here's how to use the touchscreen effectively:

Enabling the Touchscreen:

Access the Menu:

- Press the **Menu** button on the rear panel.

Enable Touch Operation:

- Navigate to the **Setup** menu.
- Select **Touch Operation** and set it to **On**.

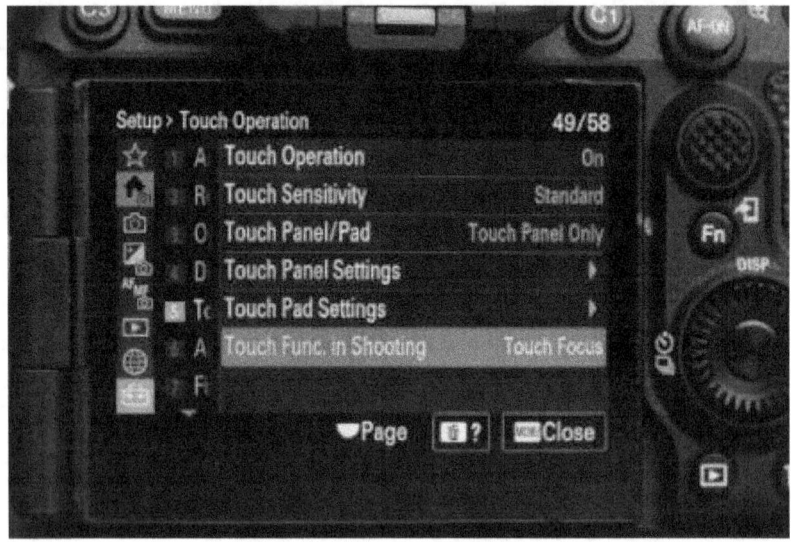

Navigating Menus:

Main Menu Navigation:

- Swipe left or right to switch between main menu tabs.
- Tap a tab to enter its menu.

Sub-Menu Navigation:

- Scroll up or down within a menu by swiping to view more options.
- Tap an item to select it.

Quick Function Menu:

- Press the Function (Fn) button to access the function menu.
- Tap directly on the desired setting to adjust it.

Controlling Focus:

Touch Focus:

- In shooting mode, tap on the screen to set the focus point. The camera will focus on the selected area.

Touch Tracking:

- Enable touch tracking in the AF menu. Tap on a subject to track it as it moves within the frame.

Touch Shutter:

- Enable touch shutter in the Shooting menu. Tap the screen to focus and take a picture simultaneously.

Reviewing Photos and Videos:

Entering Playback Mode:

- Tap the Playback button to review photos and videos.

Swipe Navigation:

- Swipe left or right to browse through your images and videos.

Zooming In and Out:

- Use two fingers to pinch out (zoom in) or pinch in (zoom out) on an image.
- Drag the image to navigate different parts while zoomed in.

Deleting Images:

- Tap the Delete button and confirm to remove unwanted photos or videos.

Customizing Touchscreen Functions:

Custom Function Settings:

- Go to the Custom Key settings in the Setup menu.
- Assign touch functions to different customizable buttons to fit your workflow.

Touch Sensitivity:

- Adjust the touchscreen sensitivity in the Touch Operation settings for a more responsive experience.

The touchscreen on the camera enhances seamless camera control. Enabling touch operations allows for easy menu navigation, quick setting adjustments, and precise focus control.

Utilize touch gestures to efficiently review and manage your photos and videos. Customize the touchscreen to match your shooting style for an optimized photography experience.

Menu Navigation

Menu navigation on the camera is crucial for managing a variety of camera settings effectively. Here's a guide on how to navigate the menu system:

Accessing the Menu:

Press the Menu Button:

- Locate the Menu button situated on the top-left side of the rear panel and press it to access the main menu.

Main Menu Structure:

Main Tabs:

- The menu is organized into several main tabs, each dedicated to different categories of settings such as Camera Settings, Network, Playback, and Setup.

- Navigate between tabs using the Multi-Selector (control wheel) or by swiping left/right on the touchscreen.

Sub-Menus:

- Each main tab contains multiple sub-menus where specific settings are grouped.

- Scroll through sub-menus by using the control wheel or swiping up/down on the touchscreen.

Navigating and Selecting Options:

Navigating Sub-Menus:

- Within each sub-menu, use the control wheel to scroll through available options or swipe up/down on the touchscreen to view more.

Selecting an Option:

- Tap the desired option directly on the touchscreen or press the center button on the Multi-Selector to select it.

Adjusting Settings:

- After selecting an option, adjust settings by turning the control wheel or using the directional pad on the Multi-Selector.
- Confirm changes by pressing the center button or tapping the setting on the touchscreen.

Quick Function Menu (Fn Button):

Accessing the Quick Function Menu:

- Press the Function (Fn) button located on the rear panel to bring up the quick function menu.

Using the Quick Function Menu:

- The quick function menu provides swift access to frequently used settings.
- Navigate through options using the control wheel or by swiping on the touchscreen.
- Adjust settings directly from this menu for expedited operation.

Customizing the Menu:

Customizing My Menu:

- Access the My Menu tab to personalize a menu with frequently used settings.

- Add items by navigating to a desired setting, pressing the DISP button, and selecting "Add to My Menu".

Custom Key Settings:

- Customize the functions of various buttons by accessing Custom Key settings within the Setup menu.

- Assign specific settings or functions to buttons to streamline access during shooting.

Searching for Settings:

Using the Help Guide:

- Press the Delete button within the menu to access the built-in help guide, which offers detailed information about selected settings.

Menu Search Function:

- Utilize the search function within the menu (if available) to swiftly locate specific settings or options.

Exiting the Menu:

Return to Shooting Mode:

- Press the Menu button again to exit the menu and return to shooting mode.

Using the Touchscreen:

- Tap the Return or Exit option displayed on the touchscreen (if available) to promptly exit the menu.

Navigating the menu on your camera involves utilizing the Menu button, Multi-Selector, and touchscreen to access and manage various camera settings.

Become familiar with the main tabs, sub-menus, and quick function menu to operate efficiently. Customize menu and button functions to align with your shooting preferences, facilitating quick adjustments.

CHAPTER FOUR
SHOOTING MODES

Shooting Modes

The Sony Alpha a7 IV offers a range of shooting modes to help you capture exceptional photos and videos in various situations. Here's an in-depth guide to each shooting mode, how to access them, and tips for maximizing their potential:

Auto Mode (Green 'AUTO' Icon):

Description:

- The camera automatically selects the optimal settings based on the scene and lighting conditions.

Use Case:

- Ideal for beginners or quick snapshots.
- Perfect when you need to capture a moment quickly without worrying about settings.

How to Use:'

- Turn the Mode Dial to the green 'AUTO' icon.
- The camera will manage everything from focus to exposure.

Program Auto (P):

Description:

- The camera sets the aperture and shutter speed, allowing you to control other settings like ISO, white balance, and exposure compensation.

Use Case:

- Useful for general photography when you want more control without going fully manual.
- Great for varied lighting conditions.

How to Use:

- Turn the Mode Dial to **P**.
- Adjust exposure compensation using the Control Dial.
- Access additional settings via the Function Menu.

Aperture Priority (A):

Description:

- You select the aperture, and the camera adjusts the shutter speed to maintain proper exposure.

Use Case:

- Ideal for controlling depth of field.
- Use a wide aperture (small f-number) for a blurred background (bokeh).
- Use a narrow aperture (large f-number) for greater depth of field, like in landscapes.

How to Use:

- Turn the Mode Dial to **A**.
- Rotate the Control Dial to select your desired aperture.
- The camera will automatically adjust the shutter speed.

Shutter Priority (S):

Description:

- You select the shutter speed, and the camera adjusts the aperture to maintain proper exposure.

Use Case:

- Perfect for capturing fast-moving subjects (e.g., sports, wildlife).
- Use a fast shutter speed to freeze motion.
- Use a slow shutter speed to create motion blur (e.g., waterfalls, light trails).

How to Use:

- Turn the Mode Dial to **S**.
- Rotate the Control Dial to select your desired shutter speed.
- The camera will automatically adjust the aperture.

Manual Exposure (M):

Description:

- You have full control over both aperture and shutter speed.

Use Case:

- Best for situations requiring precise exposure control.
- Useful for studio photography, long exposures, and challenging lighting conditions.

How to Use:

- Turn the Mode Dial to **M**.
- Rotate the Control Dial to adjust the aperture and shutter speed.
- Use the exposure meter in the viewfinder or on the screen to ensure proper exposure.

Custom Modes (1, 2, 3):

Description:

- Allows you to save and quickly access your preferred settings.

Use Case:

- Use these modes to store settings for frequently used shooting scenarios, such as specific lighting conditions or genres.

How to Use:

- Turn the Mode Dial to 1, 2, or 3.
- Set your desired settings (e.g., aperture, shutter speed, ISO).
- Save the settings by accessing the Camera Settings menu and selecting "Memory" to save them to the chosen custom mode.

Other Shooting Modes:

Scene Selection (SCN):

- Description: The camera provides pre-set modes optimized for specific scenes like Portrait, Landscape, Sports, and Night Scene.

- Use Case: Use this mode for specialized shooting scenarios to quickly apply the optimal settings.

Sweep Panorama (Panorama Icon):

- Description: Allows you to create panoramic images by sweeping the camera across the scene.
- Use Case: Great for capturing wide landscapes or large group shots.

Movie Mode (Film Camera Icon):

- Description: Optimizes settings for video recording.
- Use Case: Use this mode for shooting high-quality video with adjustable settings for resolution, frame rate, and exposure.

S&Q (Slow & Quick) Motion:

- Description: Enables shooting at varying frame rates for creating slow-motion or fast-motion videos.
- Use Case: Perfect for creative video effects requiring different playback speeds.

The camera offers a wide range of shooting modes to cater to different photography and videography needs. Understanding and selecting the appropriate mode can significantly enhance your shooting experience and the quality of your images and videos. Familiarize yourself with each mode's functions and use cases to make the most of your camera's capabilities.

CHAPTER FIVE
LENSES AND ACCESSORIES

Choosing the Right Lenses for Your Needs

Selecting the right lens for your camera is crucial for capturing high-quality images. Different lenses serve different purposes, and knowing their features and applications will help you make an informed decision. Here's a detailed guide to assist you in choosing the right lens:

Standard Zoom Lenses:

Description:

- Standard zoom lenses provide a flexible range of focal lengths, usually covering wide-angle to short telephoto.

Use Case:

- General-purpose photography.

- Ideal for travel, street photography, and everyday use.

Popular Choices:

- Sony FE 24-70mm f/2.8 GM
- Sony FE 24-105mm f/4 G OSS

Advantages:

- Versatility in framing various subjects.
- Suitable for a wide range of shooting scenarios.

Prime Lenses:

Description:

- Prime lenses have a fixed focal length, offering high image quality and wide apertures.

Use Case:

- Portrait photography, low-light conditions, and achieving a shallow depth of field.

- Suitable for creative and professional work.

Popular Choices:

- Sony FE 50mm f/1.8
- Sony FE 85mm f/1.4 GM

Advantages:

- Superior image sharpness and quality.
- Wider maximum apertures for better low-light performance and bokeh.

Wide-Angle Lenses:

Description:

- Wide-angle lenses have shorter focal lengths, capturing more of the scene in your frame.

Use Case:

- Landscape, architecture, and interior photography.
- Great for capturing expansive scenes and tight spaces.

Popular Choices:

- Sony FE 16-35mm f/2.8 GM
- Sony FE 12-24mm f/4 G

Advantages:

- Captures more of the scene in a single shot.
- Enhances perspective and depth in images.

Telephoto Lenses:

Description:

- Telephoto lenses have longer focal lengths, ideal for photographing distant subjects.

Use Case:

- Wildlife, sports, and portrait photography.
- Allows you to get close to the action without disturbing the subject.

Popular Choices:

- Sony FE 70-200mm f/2.8 GM OSS
- Sony FE 100-400mm f/4.5-5.6 GM OSS

Advantages:

- Ability to capture distant subjects in detail.
- Compresses perspective, making background elements appear closer.

Macro Lenses:

Description:

- Macro lenses are designed for close-up photography, capturing small subjects with high detail.

Use Case:

- Nature photography, product photography, and capturing fine details.
- Ideal for photographing insects, flowers, and small objects.

Popular Choices:

- Sony FE 90mm f/2.8 Macro G OSS
- Sony FE 50mm f/2.8 Macro

Advantages:

- High magnification for detailed close-up shots.
- Excellent sharpness and clarity for small subjects.

Specialty Lenses:

Description:

- Specialty lenses include fisheye, tilt-shift, and ultra-wide-angle lenses, each serving unique creative purposes.

Use Case:

- Fisheye lenses for creating distorted, spherical perspectives.
- Tilt-shift lenses for architectural photography and creative effects.
- Ultra-wide-angle lenses for immersive wide shots.

Popular Choices:

- Sony FE 12-24mm f/2.8 GM (ultra-wide-angle)
- Sony 16mm f/2.8 Fisheye

Advantages:

- Unique creative effects and perspectives.
- Specialized applications for artistic and professional work.

Tips for Choosing the Right Lens:

Identify Your Photography Style:

- Determine the type of photography you're most interested in (e.g., portraits, landscapes, sports).

Consider the Focal Length:

- Choose a focal length that suits your shooting style. Wide-angle lenses for landscapes, telephoto lenses for wildlife, etc.

Evaluate the Aperture:

- Lenses with wider apertures (e.g., f/1.8, f/2.8) are better for low-light conditions and achieving a shallow depth of field.

Check Compatibility:

- Ensure the lens is compatible with your Sony Alpha a7 IV. Sony's FE lenses are designed for full-frame cameras like the a7 IV.

Set a Budget:

- Lenses can vary greatly in price. Set a budget and find the best lens within your range that meets your needs.

Read Reviews and Test:

- Research reviews and, if possible, test the lens to see if it meets your expectations.

Choosing the right lens for your Sony Alpha a7 IV involves understanding the different types of lenses and their specific applications.

Whether you need a versatile zoom lens for everyday photography, a prime lens for portraits, or a telephoto lens for distant subjects, selecting the right lens will enhance your photographic capabilities and help you achieve your creative vision.

Essential Camera Accessories

Level up your Sony Alpha a7 IV photography with the right gear! Extra batteries, memory cards, and a camera bag are few of accessories you need. This guide explores must-have accessories to improve your shots, safeguard your equipment, and make shooting a breeze.

Extra Batteries and Charger:

- Don't miss a shot with backup batteries, perfect for long shoots or travel. (Options: Sony NP-FZ100 battery, Sony BC-QZ1 charger).

Memory Cards:

- Capture high-resolution photos and videos smoothly with fast, high-capacity memory cards. (Options: SanDisk Extreme Pro UHS-II SD card, Sony TOUGH-G Series SDXC UHS-II card).

Camera Bag:

- Keep your camera, lenses, and accessories safe and organized with a sturdy, well-designed bag. (Options: Lowepro ProTactic BP 450 AW II, Peak Design Everyday Backpack).

Tripod:

- Capture sharp low-light photos, stunning landscapes, and smooth videos with a stable tripod. (Options: Manfrotto Befree Advanced Tripod, Gitzo Series 1 Traveler Carbon Fiber Tripod).

Lens Filters:

- Enhance your images with filters that control light and add creative effects. (Options: UV filters for protection, polarizing filters for richer colors, ND filters for longer exposures).

External Flash:

- Take control of lighting with a powerful external flash for low-light situations, portraits, and creative setups. (Options: Sony HVL-F60RM Wireless Radio Flash, Godox V1 Flash for Sony).

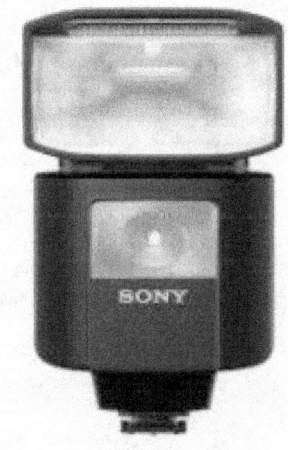

Remote Shutter Release:

- Minimize camera shake and capture self-portraits or long exposures with a remote shutter release. (Options: Sony RMT-P1BT Wireless Remote Commander, Vello FreeWave Plus Wireless Remote Shutter Release).

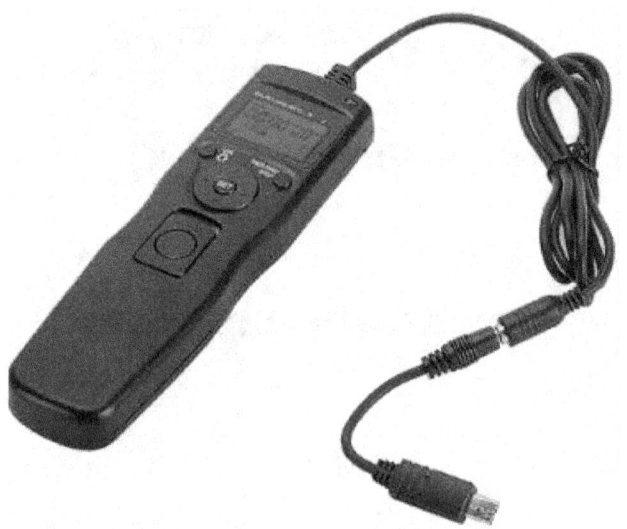

Cleaning Kit:

- Keep your camera and lenses functioning flawlessly with regular cleaning using a comprehensive cleaning kit. (Options: Giottos Rocket Blaster Air Blower, Zeiss Lens Cleaning Kit).

Screen Protector:

- Shield your camera's LCD screen from scratches and fingerprints with a screen protector. (Options: Expert Shield Glass Screen Protector, PCTC Tempered Glass Screen Protector).

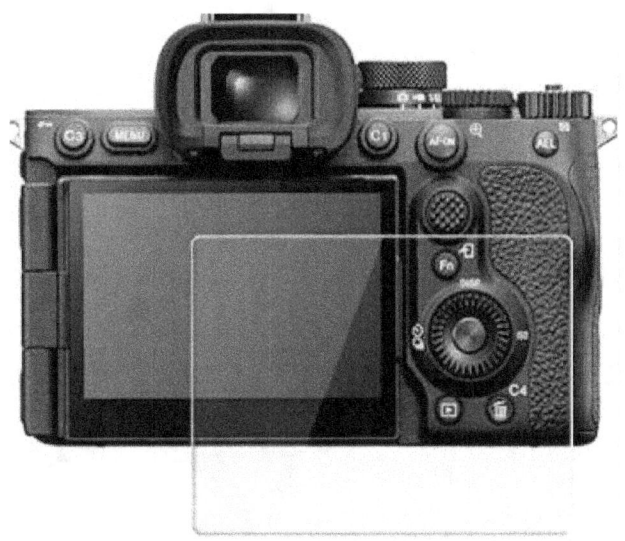

External Microphone:

Capture crisp, clear audio for your videos with an external microphone. (Options: Rode VideoMic Pro+, Sony ECM-B1M Shotgun Microphone).

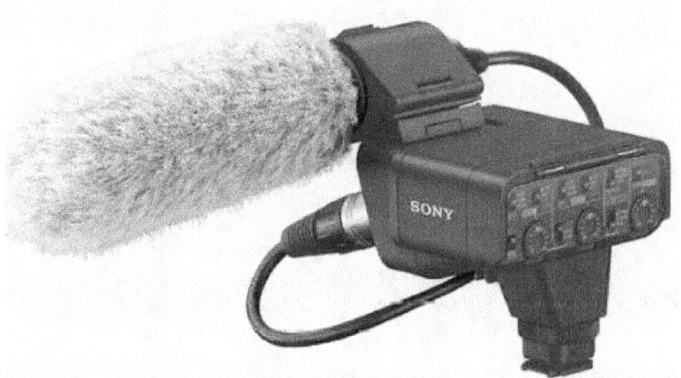

Invest in these accessories based on your shooting style to unlock the full potential of your camera and elevate your photography and videography to new heights.

CHAPTER SIX
AUTOFOCUS MASTERY

Understanding Autofocus Systems

Modern cameras like the Sony a7 IV boast powerful autofocus (AF) technology to keep your subjects perfectly sharp. This guide breaks down the different AF systems and how to use them effectively.

Autofocus (AF) Systems:

- Phase Detection AF: This speedy system uses sensor pairs to compare light and determine focus quickly. It's ideal for capturing fast-moving subjects like athletes or wildlife.

- Contrast Detection AF: This system analyzes the image on the sensor for peak contrast, indicating sharp focus. It works well for still subjects and precise focusing.

- Hybrid AF: Combining both systems, Hybrid AF offers the best of both worlds: speed and accuracy in various lighting conditions.

Choosing the Right AF Mode:

- Single-Shot AF (AF-S): Perfect for still subjects like portraits or landscapes, it locks focus with a half-press of the shutter button.

- Continuous AF (AF-C): Ideal for capturing action, it continuously adjusts focus as your subject moves.

- Automatic AF (AF-A): The camera intelligently switches between Single-Shot and Continuous AF based on subject movement.

- Manual Focus (MF): This mode provides complete control over focus using the lens ring. It's useful for macro photography or challenging focus situations.

Selecting Your Focus Area:

- The camera offers various focus areas to tailor your focus strategy:

- Wide Area: Ideal for general use, it detects focus across a large part of the frame.

- Zone: Focuses within a chosen area of the frame, useful for tracking subjects in a specific zone.

- Center: Focuses on the center of the frame, perfect for centered compositions.

- Flexible Spot: Allows you to pinpoint a small focus area for precise focusing on off-center subjects.

- Expand Flexible Spot: Similar to Flexible Spot, but uses surrounding focus points for a bit more flexibility.

- Tracking: Continuously tracks a selected subject, ideal for capturing action shots.

Advanced Features to Take Focus Further:

- Eye AF: Ensures sharp focus on your subject's eyes, perfect for portrait photography.

- Face Detection: Focuses on faces within the frame, useful for capturing groups or portraits.

- Animal Eye AF: Detects and focuses on animal eyes, ideal for wildlife photography.

Tips for Flawless Focus:

- Understand Your Subject: Choose the appropriate AF mode and focus area based on your subject's movement and position.

- Master Back-Button Focus: Separate focusing from the shutter release by assigning it to a separate button.

- Customize AF Settings: Experiment with AF sensitivity and tracking settings to optimize focus for your shooting style.

- Clean Lens and Sensor: Maintain a clean lens and sensor for optimal AF performance.

Understanding your camera's autofocus system and its features, will help you achieve sharp and captivating images in any situation.

Experiment with different settings to discover what works best for you and elevate your photography to new heights.

Customizing Focus Settings

Enhancing your Sony Alpha a7 IV's focus settings can significantly improve your ability to capture sharp, precise images in different conditions. Here's a detailed guide on how to tailor the focus settings to meet your needs:

Accessing Focus Settings:

Open the Menu:

- Press the Menu button on the rear panel to enter the camera's settings.

Navigate to Focus Settings:

- Use the Multi-Selector (control wheel) to find the Camera Settings tab. Look for the "AF/MF" (Autofocus/Manual Focus) section.

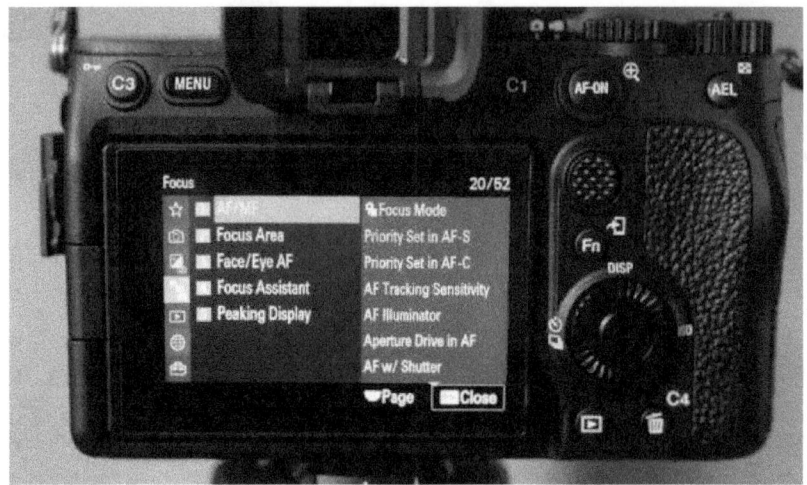

Customizing Autofocus (AF) Modes:

Select AF Mode:

- Choose from Single-Shot AF (AF-S), Continuous AF (AF-C), and Automatic AF (AF-A).

 ➢ AF-S: Ideal for still subjects.

 ➢ AF-C: Best for moving subjects.

 ➢ AF-A: Switches between AF-S and AF-C based on subject movement.

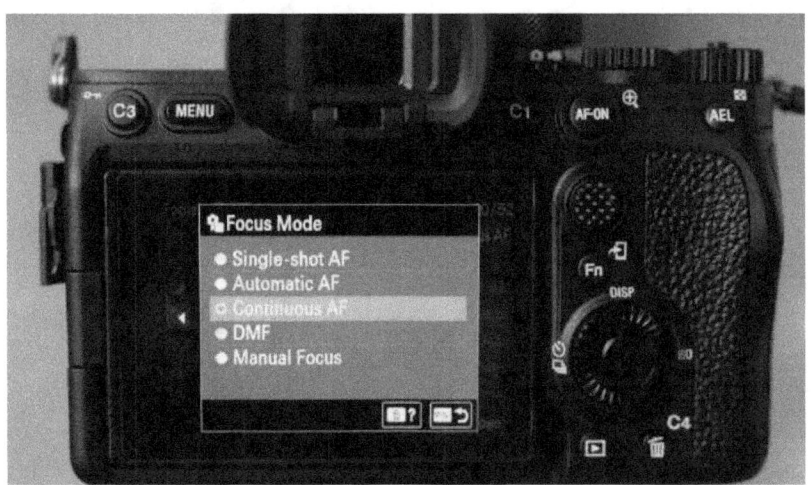

Adjust AF Area Mode:

- Select the frame area for focusing:
 - ➢ Wide: Uses the whole frame.
 - ➢ Zone: Focuses within a specified zone.
 - ➢ Center: Focuses on the center of the frame.
 - ➢ Flexible Spot: Manually select a specific focus point.
 - ➢ Expand Flexible Spot: Includes surrounding points to maintain focus on moving subjects.

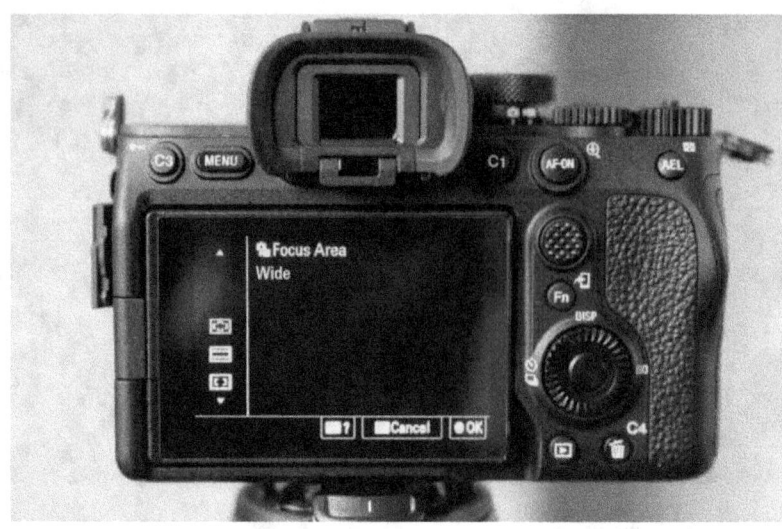

Customizing Manual Focus (MF) Settings:

Switch to Manual Focus:

- Turn the focus mode dial on the lens to "MF" or select Manual Focus in the camera menu.

Use Focus Magnifier:

- Press the Focus Magnifier button to zoom in for precise manual focusing.

Peaking Level and Color:

- Enable focus peaking in the menu to highlight in-focus areas with a specific color. Adjust the peaking level (low, mid, high) and select a color (red, yellow, white).

Setting Up Eye AF and Real-Time Tracking:

Enable Eye AF:

- In the AF/MF menu, enable Eye AF for accurate focusing on human eyes. Choose automatic, left eye, or right eye priority.

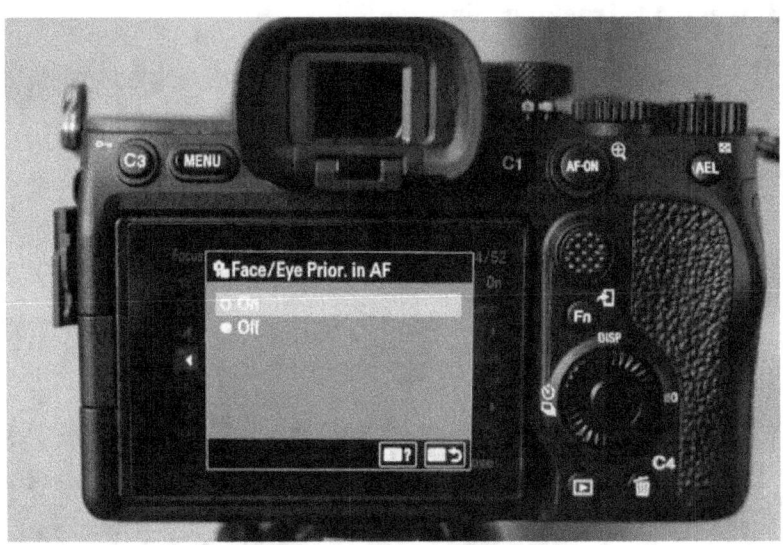

Activate Real-Time Tracking:

- Enable Real-Time Tracking in the AF area mode settings. This feature uses AI to track subjects, maintaining focus even as they move.

Customizing Focus Hold and AF-On Buttons:

Assign Functions to Custom Buttons:

- Go to the Custom Key settings in the Setup menu.
- Assign commonly used focus functions (e.g., AF-On, Eye AF) to specific buttons for quick access.

Use the Focus Hold Button:

- Some lenses have a Focus Hold button that can be customized. Assign functions like focus lock or Eye AF to this button for convenient use.

Adjusting AF Tracking Sensitivity:

AF Tracking Sensitivity:

- Adjust the AF tracking sensitivity in the AF/MF settings to control how quickly the focus shifts between subjects.
 - ➤ Locked-On (Low): Best for steady subjects with minimal focus changes.
 - ➤ Responsive (High): Ideal for fast-moving subjects or quick focus adjustments.

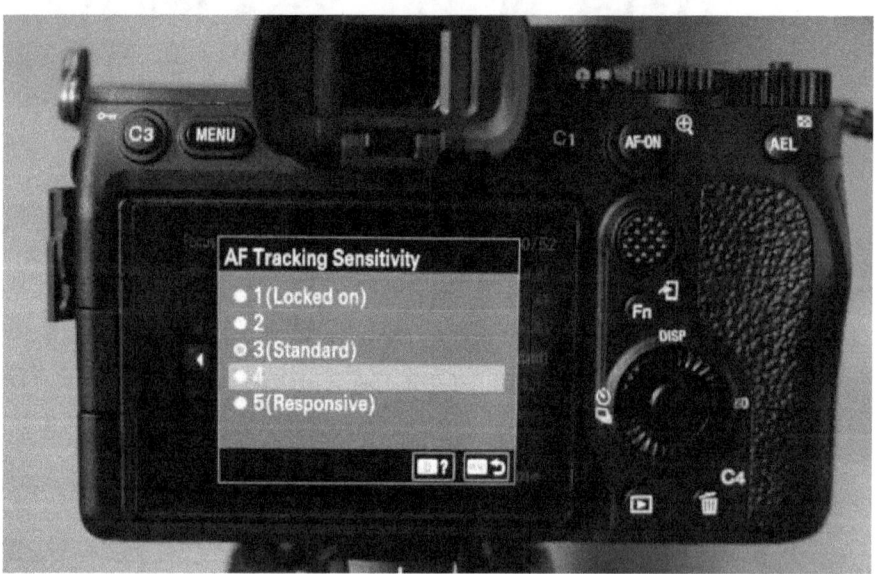

Saving Custom Settings:

Save to Custom Modes:

- After configuring your focus settings, save them to one of the custom modes (1, 2, 3) on the mode dial for easy access in future shoots.

Customizing focus settings on camera helps optimize the camera's autofocus and manual focus capabilities for various scenarios. The menu structure may vary slightly depending on your camera's firmware version.

CHAPTER SEVEN
EXPOSURE CONTROL

Understanding Exposure Triangle: Aperture, Shutter Speed, ISO

Understanding the exposure triangle—comprising aperture, shutter speed, and ISO—is essential in photography as it dictates how light interacts with your camera to create well-exposed images and artistic effects.

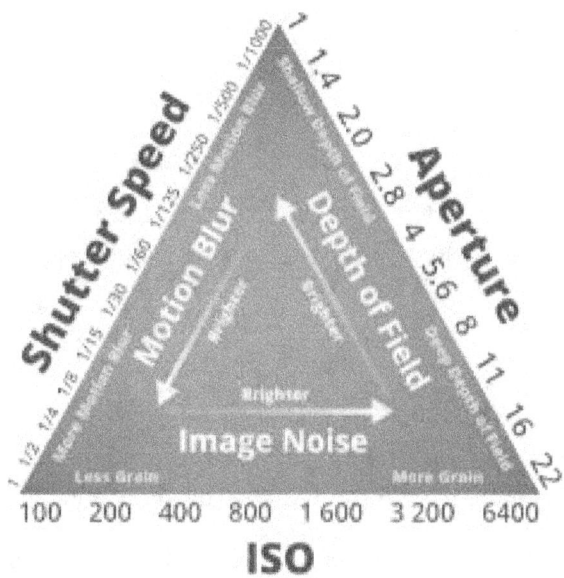

Aperture:

- Definition: Aperture denotes the opening in the lens that regulates light entering the camera, measured in f-stops (e.g., f/1.8, f/4, f/16).

- Effects:
 - Exposure: Larger apertures (smaller f-numbers) increase light intake, yielding brighter images, while smaller apertures (larger f-numbers) reduce light for darker images.
 - Depth of Field: Aperture controls depth of field—wider apertures (e.g., f/1.8) create shallow depth, blurring backgrounds; narrower apertures (e.g., f/16) enhance depth, keeping more in focus.
- Adjust via Control Dial in Aperture Priority (A or Av) or Manual (M) mode.

Shutter Speed:

- Definition: Shutter speed determines how long the camera sensor is exposed to light, measured in seconds or fractions (e.g., 1/1000s, 1/60s, 1s).
- Effects:
 - Exposure: Faster speeds (e.g., 1/1000s) reduce light, resulting in darker images; slower speeds (e.g., 1/60s) increase light, producing brighter images.
 - Motion Blur: Fast speeds freeze action, ideal for capturing movement; slow speeds introduce blur, conveying motion.
- Control Dial in Shutter Priority (S or Tv) or Manual (M) mode manages shutter speed.

ISO:

- Definition: ISO measures sensor sensitivity to light, with higher values (e.g., ISO 1600) enhancing sensitivity in low light.

- Effects:

 ➤ Exposure: Higher ISO brightens images in dim conditions; excessive ISO may add digital noise, affecting quality.

 ➤ Noise/Grain: Lower ISO levels produce cleaner images; higher levels can introduce visible noise, especially in darker areas.

- Set through camera menu or dedicated ISO button, depending on configuration.

Balancing the Exposure Triangle:

- Bright Conditions: Opt for smaller apertures, faster shutter speeds, and lower ISO.

- Low-Light Conditions: Use larger apertures, slower shutter speeds (consider tripod), and higher ISO to maintain exposure.

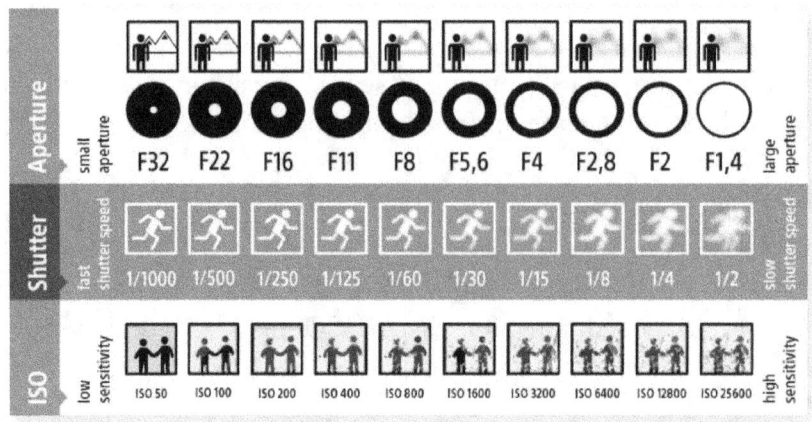

Examples:

- Portrait Photography: Utilize wider apertures (e.g., f/2.8), moderate shutter speeds, and low ISO for clarity.

- Landscape Photography: Choose narrower apertures (e.g., f/8+), tripod for stability, and adjust ISO cautiously.

- Action Photography: Prefer fast shutter speeds (e.g., 1/1000s+), moderate apertures, and vary ISO to balance exposure.

Understanding and experimenting with the exposure triangle empowers photographers to control light creatively and achieve desired photographic outcomes with your camera across diverse shooting conditions.

Manual vs. Automatic Exposure Modes

Knowing the difference between automatic and manual exposure modes on your Sony Alpha a7 IV is like understanding the difference between letting your camera be the driver or taking the

wheel yourself. This guide explains how each mode works and helps you pick the best one for your situation.

Automatic Modes:

Automatic exposure modes take the guesswork out of exposure. The camera analyzes the scene and sets the aperture, shutter speed, and ISO for you. Here's a breakdown of the available options:

- Program Auto (P) Mode: This mode is like having a co-pilot. The camera sets aperture and shutter speed automatically, but you can still adjust things like ISO and exposure compensation if needed. It's a good choice for general photography when you want to make quick changes without getting bogged down in settings.

- Aperture Priority (A or Av) Mode: In this mode, you're the captain of the depth of field. You choose the aperture (which controls background blur), and the camera sets the shutter speed to get a good exposure. This is ideal for portraits or landscapes where you want to control how much of the scene is in focus.

- Shutter Priority (S or Tv) Mode: Here, you become the master of motion. You choose the shutter speed (to freeze action or show motion blur), and the camera sets the aperture for proper exposure. This is perfect for capturing sports or other moving subjects.

Taking the Wheel: Manual Mode

Manual exposure mode gives you complete control over everything – aperture, shutter speed, and ISO. It's like having a high-performance car; it offers incredible flexibility but requires more skill to use effectively.

- Manual (M) Mode: In this mode, you're in total control. You set both the aperture and shutter speed, and the camera gives you a meter to help you judge the exposure. This is best for situations where you need precise control, like studio photography, long exposures, or tricky lighting.

Which Mode Should You Use?

- Automatic Modes: These are great for quick shots, beginners, or situations where things are changing fast. However, you give up some creative control over how the image looks.

- Manual Mode: This mode lets you unleash your creativity and get exactly the exposure you want. But it takes practice and knowledge of exposure to use well, especially in difficult lighting.

Understanding both automatic and manual exposure modes lets you choose the right tool for the job on your Sony Alpha a7 IV.

Automatic modes are fast and easy, while manual mode gives you ultimate control. Mastering both lets you adapt to any situation and capture stunning photos.

Exposure Compensation

Exposure compensation is a crucial feature found on the Sony Alpha a7 IV and similar cameras, empowering photographers to modify the camera's automatic exposure settings to achieve their desired levels of brightness in photographs. Here's an exploration of exposure compensation and its operational dynamics:

Understanding Exposure Compensation:

Definition: Exposure compensation, denoted as "EV" or "±EV", allows users to adjust the exposure value set by the camera's metering system. It's typically measured in stops, where each stop represents a doubling or halving of the amount of light entering the camera.

Purpose: The primary objective of exposure compensation is to rectify the camera's automatic exposure settings when they fail to accurately capture the scene's brightness as perceived by the photographer. It proves especially beneficial in scenarios where subjects appear exceptionally bright or dark compared to their surroundings, or when deliberate overexposure or underexposure is desired for artistic effect.

Operational Mechanics of Exposure Compensation:

Accessing Exposure Compensation:

- On your camera, exposure compensation adjustments are made via the Control Dial or a dedicated exposure compensation button, typically marked with a "+/-" symbol.

- In automatic and semi-automatic modes like Aperture Priority or Shutter Priority, tweaking exposure compensation alters the camera's recommended settings without necessitating full manual control.

Range of Adjustment:

- Exposure compensation typically spans from -3 EV to +3 EV, with adjustments in increments of 1/3 or 1/2 stops. Each increment corresponds to specific modifications in exposure parameters, such as altering shutter speed or aperture size.

Practical Applications:

- Overexposure: Increase exposure compensation (e.g., +1 EV or higher) to brighten an image, particularly useful in scenes with predominantly dark tones or when emphasizing details in shadows.

- Underexposure: Decrease exposure compensation (e.g., -1 EV or lower) to darken an image, effective for scenes with bright highlights or when creating silhouettes against bright backgrounds.

Strategic Utilization of Exposure Compensation:

- Challenging Lighting Conditions: Use exposure compensation to balance exposures in scenes with significant variations between light and dark areas.

- Backlit Subjects: Adjust exposure compensation to properly expose subjects when shooting against bright backgrounds, preventing them from appearing as dark silhouettes.

- Artistic Expression: Employ exposure compensation deliberately to achieve specific creative effects or to align with the desired mood of a photograph.

Application Scenarios on the Sony Alpha a7 IV:

- Aperture Priority Mode: Employ exposure compensation to manage the camera's selection of shutter speed while maintaining control over the chosen aperture setting.

- Shutter Priority Mode: Adjust exposure compensation to influence aperture choices for controlling depth of field, with the camera managing shutter speed accordingly.

Program Auto Mode: Fine-tune automatic exposure settings based on scene brightness using exposure compensation for optimal results.

CHAPTER EIGHT
IMAGE QUALITY SETTINGS

Selecting Image File Formats: RAW vs. JPEG

Choosing the appropriate image file format, whether RAW or JPEG, for your camera depends on your particular needs and workflow. Here's an overview of both formats to assist you in making a decision:

RAW Format:

Description:

- RAW files contain minimally processed data directly from the camera's sensor.

- High-quality, uncompressed image data that captures all details and tones.

- Offers extensive editing capabilities in post-processing without compromising quality.

- Captures a broader dynamic range compared to JPEG, preserving details in highlights and shadows.

- Larger file size due to uncompressed data.

Advantages:

- Ideal for professional photographers who require precise control over image processing.

- Enables correction of exposure, white balance, and other settings without degradation.

- Retains the highest possible image quality and detail.

Considerations:

- Requires post-processing to convert and edit RAW files.
- Larger file sizes consume more storage space on memory cards and hard drives.
- Not directly usable for sharing or quick viewing without conversion.

JPEG Format:

Description:

- JPEG files are compressed and processed in-camera.
- Good quality with smaller file sizes suitable for sharing and quick viewing.
- Ready-to-use images straight from the camera.
- Smaller file sizes save storage space on memory cards and computers.
- In-camera processing includes settings like white balance, sharpness, and color saturation.

Advantages:

- Quick and easy to share directly from the camera or after minimal editing.
- Suitable for situations where immediate sharing or printing is necessary.
- Lower storage requirements compared to RAW files.

Considerations:

- Limited editing capabilities compared to RAW due to compression.

- May lose some image details and dynamic range during processing.

- Not ideal for extensive post-processing or professional-level editing needs.

Selecting RAW or JPEG on Your Camera:

Navigate to MENU → (Shooting) → [Image Quality] → [Image Quality Settings] → [File Format] → choose your preferred option.

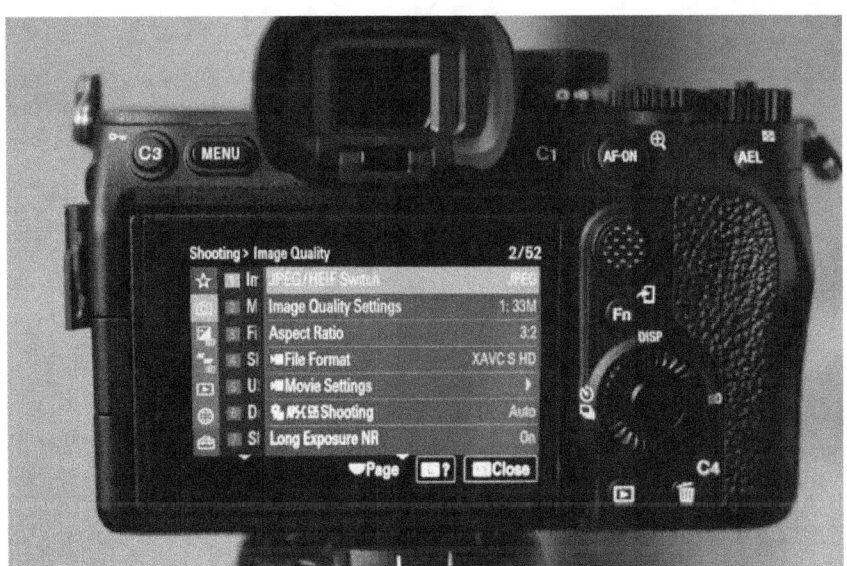

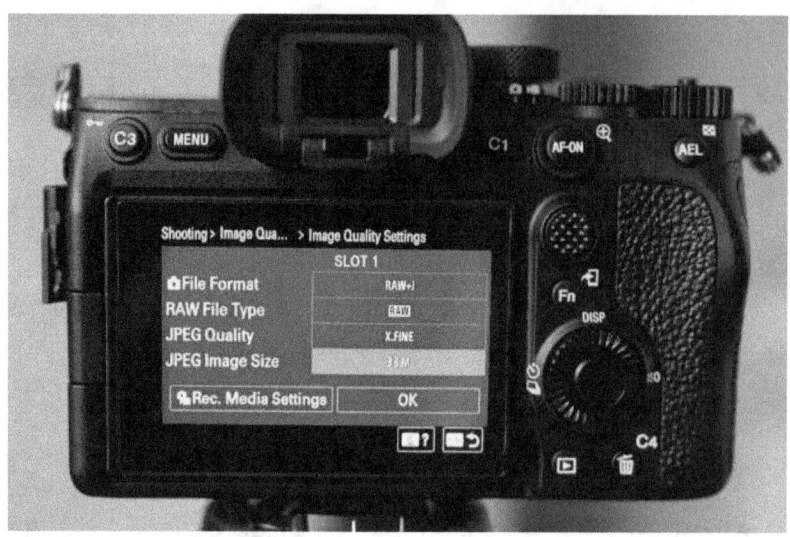

Making the Right Choice:

Use RAW if:

- You need maximum editing flexibility and control over image processing.

- You're shooting in challenging lighting conditions where preserving dynamic range is critical.

- Your work demands the highest image quality and detail.

Use JPEG if:

- You require images ready for quick sharing or printing without additional editing.

- Storage space is a concern, and you want to conserve memory card capacity.

- Your photography involves casual shooting where extensive post-processing is unnecessary.

Selecting between RAW and JPEG on your Sony Alpha a7 IV hinges on your specific requirements for image quality, editing flexibility, and workflow efficiency.

RAW offers unparalleled control and quality but necessitates post-processing, while JPEG provides convenience and smaller file sizes suitable for immediate use.

Choose based on your shooting style, intended use of the images, and editing preferences to optimize your photographic workflow.

Adjusting Picture Profiles and Creative Looks
Picture Profiles:

Allow you to adjusting the settings for color, gradation, and more.

While **[Picture Profile]** can be used for both still images and movies, its primary function is designed for movies.

Customizing Picture Profile:

- You can customize picture quality by adjusting parameters such as [Gamma] and [Detail]. To set these parameters, you connect the camera to a TV or monitor and adjust while viewing the picture on the screen.

- Access Menu: MENU → (Exposure/Color) → [Color/Tone] → [Picture Profile] → select the profile you want to change.

- Navigate: Move to the item index screen by pressing the right side of the control wheel.

- Adjust Settings: Use the top/bottom sides of the control wheel to select the item to change, then press the center to select the desired value.

Using Picture Profile Presets:

Default settings [PP1] through [PP11] for movies are pre-set based on various shooting conditions in the camera.

MENU → (Exposure/Color) → [Color/Tone] → [Picture Profile] → desired setting.

Creative Looks:

"Looks" are preset styles for image creation preinstalled on the camera.

With this function, choose the finish of the image by selecting a "Look." Additionally, adjust contrast, highlights, shadows, fade, saturation, sharpness, sharpness range, and clarity for each "Look."

- Access Menu: MENU → (Exposure/Color) → [Color/Tone] → [Creative Look].

- Select Look: Use the top/bottom sides of the control wheel to select the desired "Look" or [Custom Look].

- Adjust Parameters: Move to the right using the right side of the control wheel to adjust (Contrast), (Highlights), (Shadows), (Fade), (Saturation), (Sharpness), (Sharpness Range), and (Clarity). Select the desired item using the right/left sides and adjust the value using the top/bottom sides.

Registering Preferred Settings (Custom Look):

Select one of the six custom look boxes (numbered on the left side) to register preferred settings. Then, adjust settings using the right button. You can recall the same "Look" presets with slightly different settings.

Detailed Adjustment:

- Each "Look" allows detailed adjustment of items such as contrast according to your preferences. Adjust not only preset "Looks" but also each [Custom Look], allowing you to register your favorite settings.

Adjusting Values:

- Select an item to set by pressing the right/left sides of the control wheel, then set the value using the top/bottom sides of the control wheel.

- When changing a setting value from its default, an asterisk (*) is added next to the "Look" icon displayed on the shooting screen.

Resetting Adjusted Values for Each "Look":

- Reset adjusted values, such as contrast, collectively for each "Look." Press the (delete) button on the adjustment screen for the "Look" you want to reset. All adjusted values will return to their default values.

Using White Balance Settings

Adjusts the color temperature to accurately capture neutral white under the current ambient lighting conditions. Use this function if the image's color tones are unexpected or to intentionally alter color tones for creative purposes.

Steps to Adjust White Balance:

- Navigate to MENU → (Exposure/Color) → [White Balance] → [White Balance] → select desired setting.

Menu Options:

- Auto / Auto: Ambience / Auto: White / Daylight / Shade / Cloudy / Incandescent / Fluor.: Warm White / Fluor.: Cool White / Fluor.: Day White / Fluor.: Daylight / Flash (for still images only) / Underwater Auto:

- Automatically adjusts color tones based on selected light sources (preset white balance). "Auto" detects light sources automatically.

- C.Temp./Filter: Adjusts color tones based on light source, simulating effects of CC (Color Compensation) filters for photography.

- Custom 1/Custom 2/Custom 3: Stores basic white balance settings for specific shooting environments.

Hints:

- Fine adjustments can be made by pressing the right side of the control wheel to display the fine adjustment screen. For "C.Temp./Filter," adjust color temperature using the rear dial.

- Use [WB bracket] shooting if color tones do not meet expectations in selected settings.

- [Auto: Ambience] and [Auto: White] are available when [Priority Set in AWB] is set to [Ambience] or [White].

- Enable [Shockless WB] to smoothly transition white balance during movie recording.

Notes:

- In [Intelligent Auto] mode, [White Balance] is fixed to [Auto].

Use of mercury or sodium lamps may result in inaccurate white balance; consider using flash or selecting [Custom 1] to [Custom 3] presets for accurate results.

CHAPTER NINE
VIDEO RECORDING

Frame Rates and Resolutions

Understanding how you record video on your camera involves considering two critical factors: frame rates and resolutions, which profoundly impact the quality and visual style of your footage. Familiarizing yourself with these aspects will help you select the optimal settings to achieve your desired creative results.

Frame Rate: Capturing Motion Smoothly

Imagine a flipbook where faster page flips create smoother animation. Frame rate (fps) works similarly by determining how many frames (individual images) your camera captures per second. Here's what different frame rates mean for your videos:

- 24 fps: This cinematic standard provides a natural, smooth look suitable for most video projects and films.

- 30 fps: Commonly used for its balance between smoothness and manageable file sizes, ideal for general video applications.

- 60 fps: Excellent for capturing fast-moving action, such as sports or wildlife, with the added benefit of enabling smooth slow-motion effects during editing. However, higher frame rates result in larger file sizes.

Resolution: Level of Detail

Resolution refers to the number of pixels comprising each video frame, akin to building blocks that determine sharpness and detail. Here are the common resolutions you'll encounter:

- HD (High Definition): 1920 x 1080 pixels, widely used for online videos and basic home recordings.

- Full HD (Full High Definition): Essentially the same as HD (1920 x 1080 pixels), often referred to for clarity.

- 4K (Ultra High Definition): 3840 x 2160 pixels, offering four times the resolution of HD, ensuring exceptional detail and clarity, particularly suitable for professional applications or future-proofing your videos.

The Sony Alpha a7 IV and Your Choices:

The Sony Alpha a7 IV provides extensive flexibility in both frame rates and resolutions for 4K video recording:

- Frame Rates: Options include 24p, 30p, and even 60p for 4K recording, allowing you to capture cinematic footage or fast-paced action with the potential for smooth slow-motion effects.

- Resolutions: When recording at 24p or 30p in 4K, the camera utilizes the full width of its full-frame sensor, maximizing detail and image quality. Switching to 60p activates a Super 35 crop mode, which offers benefits like enhanced stability but with a slightly narrower field of view.

Choosing the Right Combination:

Selecting the best frame rate and resolution combination depends on your specific shooting scenario and desired video outcome:

- For Cinematic Projects: Opt for 4K at 24p to achieve a classic cinematic look.

- For General Video Purposes: Choose 4K at 30p for a balance of smoothness and manageable file sizes.
- For Capturing Action: Use 4K at 60p to effectively capture fast-paced scenes and utilize slow-motion effects in post-production.

Note: Higher frame rates and resolutions typically result in larger file sizes, so consider your storage capacity and editing capabilities when choosing settings.

By understanding frame rates and resolutions, you can effectively harness the video recording capabilities of your camera, capturing visually stunning footage aligned with your creative vision.

<u>Using S-Log3 and HLG for Professional Video</u>

The camera offers advanced video capabilities through S-Log3 and HLG gamma profiles, each playing a crucial role in shaping post-production workflows and final video quality. Here's an in-depth exploration of these color profiles:

S-Log3: Versatility and Dynamic Range

- Definition: S-Log3 is a logarithmic gamma profile designed to capture a broader dynamic range than standard profiles, preserving details in both bright highlights and deep shadows.

Advantages:

- Enhanced Post-Production Control: S-Log3 footage appears flat and low in saturation during capture, intentionally offering extensive control over color grading in post-production. This allows manipulation of colors, contrast

adjustments, and detailed recovery in highlights and shadows to achieve desired visual effects.

- Expanded Dynamic Range: S-Log3 captures a wide array of color information, crucial for extracting details from darker areas or overexposed highlights, particularly useful in scenes with high contrast.

Considerations:

- Requires Post-Production Expertise: Maximizing the potential of S-Log3 necessitates proficiency in color correction software and a more intricate editing process.

- Flat Initial Appearance: Footage shot in S-Log3 may appear lackluster when viewed directly from the camera, but its true potential unfolds during post-production grading.

HLG (Hybrid Log Gamma): Optimized for Direct Viewing

- Definition: HLG is a newer HDR (High Dynamic Range) profile tailored for viewing on HDR-compatible displays, offering an expanded dynamic range with a natural-looking image compared to S-Log3.

Advantages:

- Near-Final Appearance Out-of-Camera: HLG footage closely resembles the final graded look straight from the camera, making it suitable for client presentations or immediate social media sharing.

- Simplified Workflow: HLG requires less intensive color correction compared to S-Log3, potentially streamlining the post-production process.

Considerations:

- Less Post-Production Flexibility: While HLG offers good dynamic range, it captures fewer color details than S-Log3, limiting extensive creative control during grading.

- Requires HDR Display: To fully appreciate HLG's benefits, viewers need an HDR-compatible display; otherwise, the footage may appear muted on standard screens.

Choosing the Right Profile:

Guidance for selection:

- For Maximum Creative Control and Dynamic Range: Opt for S-Log3 if you prioritize extensive post-production flexibility and are comfortable investing time in detailed color grading.

- For Efficient Workflow and Near-Final Results: Choose HLG if you seek a quicker editing process with a visually appealing look straight from the camera, especially when your audience has access to HDR displays.

Additional Tips:

- Utilize a calibrated monitor for accurate color grading, crucial when working with S-Log3 footage.

- Explore LUTs (Lookup Tables) as starting points for grading S-Log3 footage, enhancing efficiency in post-production.

Mastering S-Log3 and HLG on your Sony Alpha a7 IV opens doors to professional video production, enabling you to capture exceptional visuals and achieve your desired cinematic style effectively.

Audio Recording Options

The camera doesn't just focus on exceptional visuals; it also prioritizes high-quality audio capture. Here's an overview of your audio recording choices:

Internal Microphone:

- Built-in Convenience: The a7 IV includes an internal microphone for basic audio recording, convenient for capturing ambient sounds or quick videos without needing external audio gear.

- Limitations: The built-in microphone may capture unwanted camera noises like autofocus sounds or handling noise. It might not provide the same clarity and directional focus as external microphones.

Audio Recording Settings:

You can choose whether to record sounds during movie shooting. Selecting [Off] prevents recording of lens and camera operation sounds. This function isn't available during slow-motion or quick-motion shooting.

- Navigate to MENU → (Shooting) → [Audio Recording] → [Audio Recording] → choose your preferred setting.

Menu Details:

On:

- Records sound during movie shooting.

Off:

- Does not record sound during movie shooting.

External Microphone Input:

- Enhanced Audio Quality: For professional-grade audio, the a7 IV offers a 3.5mm microphone jack to connect external microphones. This allows flexibility with microphone types depending on your recording requirements.

Manual Audio Level Control:

- Precise Sound Adjustment: The camera allows manual adjustment of audio recording levels, ensuring audio is neither too quiet nor distorted, crucial when using external microphones.

- Monitoring Audio Levels: Keep an eye on the on-screen audio level meter during recording to prevent clipping (excessively loud audio) and maintain optimal sound quality.

Choosing the Right Option:

Selection depends on your shooting scenario and desired results:

- For Casual or Basic Videography: Internal microphone may suffice.

- For Interviews, Vlogging, or Situations Needing Clear Audio: Consider external microphones like shotgun or lavalier mics.

- For Professional-Grade Productions: External audio recorder offers maximum control over audio quality.

By understanding the audio recording capabilities of your camera and selecting the appropriate tools, you can enhance the audio quality of your videos, providing a more immersive experience for your audience.

CHAPTER TEN
ADVANCED SHOOTING TECHNIQUES

Low Light Photography

The Sony Alpha a7 IV excels not only in daylight but also in challenging low-light conditions. Here's a refined guide on maximizing its capabilities to capture exceptional images even in dim environments:

Harnessing Low ISO Effectively:

- Reducing Noise: Achieving clean, low-light photos hinges on keeping the ISO (sensor sensitivity) low. Lower ISO settings preserve detail and minimize digital noise, preserving image quality.

- Starting Point: Begin with ISO settings around 100 or 200 in low-light situations, aiming for the cleanest possible images under available lighting conditions.

Optimizing Aperture for Light Intake:

- Embrace Wide Apertures: The aperture regulates how much light enters the lens. Wider apertures (lower f-numbers) are critical in low-light settings, maximizing light intake.

- Utilizing Maximum Aperture: Most Sony Alpha a7 IV lenses offer wide maximum apertures (like f/1.8 or f/2.8). Utilize these settings to capture more light and achieve a shallow depth of field for selective focus.

Determining Ideal Shutter Speed:

- Balancing Sharpness and Motion: Shutter speed dictates how long the camera sensor is exposed to light. In low light, slower shutter speeds are necessary for adequate light capture, but they can lead to motion blur if there's movement.

- Experimentation is Key: Start with shutter speeds around 1/60th of a second and adjust based on your scene dynamics and desired outcome. Increase shutter speed if motion blur occurs, while considering compensatory ISO adjustments.

Leveraging Image Stabilization:

- Steady Handheld Shots: Benefit from the camera's robust built-in image stabilization (IBIS), which counters camera shake. This feature enables sharper handheld shots in low light, enhancing overall image clarity.

Utilizing a Tripod for Stability:

- Enhanced Stability: For extremely low light or prolonged exposures, a tripod ensures absolute camera stability. It facilitates the use of slower shutter speeds, maximizing light capture and detail preservation.

Optimizing Focus with Focus Peaking:

- Enhanced Focusing Precision: Leverage the a7 IV's focus peaking feature, which highlights in-focus areas with colored lines. This tool is invaluable for achieving precise focus in low-light scenarios, where relying solely on the viewfinder may pose challenges.

Additional Techniques and Considerations:

- Capture in RAW: RAW file formats retain more image data compared to JPEGs, offering greater flexibility in noise reduction and post-processing adjustments.

- Experiment with Exposure Bracketing: Capture multiple exposures with slight variations to ensure optimal exposure, particularly useful in scenes with high contrast or varying light conditions.

- Explore Flash Techniques: While not suitable for every scenario, flash photography can augment low-light shots by providing fill light. Techniques such as bouncing flash off surfaces like walls or ceilings can soften lighting effects.

High-Speed Photography

The Sony Alpha a7 IV excels not just in everyday photography but also in capturing fleeting moments through high-speed photography. Here's how to maximize its capabilities:

- Fast Shutter Speeds: Use shutter speeds as fast as 1/8000th of a second to freeze fast-moving subjects like splashing water or birds in flight.

- Fast Lens Compatibility: Pair with lenses featuring wide apertures (e.g., f/1.8, f/2.8) to compensate for reduced light intake during fast shutter speeds, ensuring sharp images even in low light.

- Focus Precision: Utilize advanced autofocus features, such as real-time tracking, to maintain focus on fast-moving subjects. Experiment with different autofocus modes like AF-C for optimal results.

- Burst Mode Efficiency: Capture rapid sequences of images using the a7 IV's burst mode, enabling you to seize the peak action in a single frame. Adjust burst rates for high-speed performance while managing file sizes.

- Silent Shooting Option: Opt for the electronic shutter for noise-free operation, beneficial in sensitive shooting environments like wildlife photography.

Additional Techniques:

- Enhance focus precision with pre-focus and recompose methods. Utilize external flash units with high-speed sync for added lighting control in low-light conditions.

- Practice and Refinement: Master high-speed photography through practice and experimentation, starting with slower subjects and gradually advancing to faster actions.

In essence, the Sony Alpha a7 IV empowers photographers to capture dynamic high-speed moments with precision and creativity. Understanding these fundamentals and honing your skills will elevate your photography to new heights.

Time-Lapse and Interval Shooting

Sony Alpha a7 IV excels at creating stunning time-lapse and interval shooting sequences. Here's how to make the most of these features:

Time-Lapse Shooting:

Definition: Time-lapse photography involves taking a series of photos at regular intervals and combining them into a video to showcase slow changes over time, such as sunsets, blooming flowers, or busy streets.

How to Shoot a Time-Lapse:

- Set the Interval: Choose the interval between shots based on how fast your subject is moving. For slow subjects like a sunset, intervals of 1-5 seconds work well.

- Determine Duration: Decide on the length of your final time-lapse. For a 10-second time-lapse at 24 frames per second (fps), you'll need 240 shots.

- Manual Settings: Use manual mode for consistent exposure. Adjust ISO, aperture, and shutter speed according to the lighting conditions.

- Use a Tripod: A tripod is essential for keeping the camera stable and preventing movement between shots.

- Start Shooting: Utilize the a7 IV's built-in intervalometer to set the interval and number of shots. The camera will handle the rest.

Post-Processing:

- Import your photos into video editing software.

- Compile the images into a video sequence, typically at 24 or 30 fps.

Interval Shooting:

Definition: Interval shooting captures images at regular intervals without necessarily combining them into a video. It's ideal for creating photo series or assembling a time-lapse manually later on.

How to Shoot Intervals:

- Set Intervalometer: Configure the a7 IV's intervalometer for the desired shooting frequency.

- Manual Exposure: Use manual settings to maintain consistent exposure across shots.

- Focus Settings: Set focus manually or use continuous autofocus (AF-C) for moving subjects.

- Stability and Composition: Use a tripod for stability and carefully compose your shot.

- Start Shooting: Initiate the interval shooting sequence, and the camera will automatically take photos at the set intervals.

Tips for Success:

- Battery and Memory: Ensure a full battery or external power source and use a high-capacity memory card.

- Weather: Check weather conditions to avoid disruptions during outdoor shoots.

- Review and Adjust: Periodically review your shots to ensure your settings are correct.

Panorama and HDR Imaging

The camera offers powerful tools for capturing breathtaking panoramas and HDR images. Let's dive into how to use these features:

Panoramic Perfection: Capturing Sweeping Vistas

Imagine fitting an entire breathtaking landscape or city skyline into a single frame. Panoramic photography makes it possible! Here's how to:

- Mode Selection: Switch your camera to the designated "Panorama" mode.

- Panning Direction: Choose the direction you'll move the camera, whether left to right, right to left, up, or down.

- Tripod for Steadiness (Optional): While not essential, a tripod ensures smooth and even panning for seamless results.

- Overlapping Shots: Aim for roughly 30-50% overlap between each image captured. This helps the camera stitch the final panorama flawlessly.

- Capture the Scene: Press the shutter button and smoothly pan your camera across the scene in your chosen direction.

HDR: Unveiling the Full Dynamic Range

High Dynamic Range (HDR) takes your photos a step further. It captures a wider range of light and detail, preserving highlights and shadows in a single image. Here's how to achieve stunning HDR with your camera:

- Activate HDR Mode: Navigate to the camera menu and enable the HDR function.

- Exposure Options: Choose the number of exposures and the range of exposure values you want to capture (e.g., 3 shots at -2, 0, and +2 EV).

- Steady Shots: Utilize a tripod to ensure your camera stays stable for all the bracketed exposures the camera will take.

- Capture the Series: The camera will automatically capture the bracketed images and merge them into a single HDR image.

Pro Tips for Panoramas and HDR:

Panoramic Pointers:

- Manual Settings: Maintain consistency throughout your panorama by using manual exposure and white balance settings.

- Vertical Panoramas: Experiment with shooting vertically to capture more of the scene's height.

- Level Up Your Horizon: Ensure a level horizon in each shot to avoid a distorted final image.

HDR Hints:

- RAW Power: Shoot in RAW format to preserve maximum detail and editing flexibility in post-processing.

- Keep it Static: HDR excels with stationary scenes. Moving objects can cause unwanted ghosting effects in the final image.

- Auto Exposure Bracketing (AEB) Advantage: Utilize AEB for precise control over the range of exposures captured in your HDR image.

Mastering these techniques and leveraging the Sony Alpha a7 IV's panorama and HDR capabilities will help you create expansive, detailed images that truly capture the essence of any scene.

So, grab your camera, explore these features, and get ready to capture stunning, high-quality photos that will leave a lasting impression.

CHAPTER ELEVEN
CONNECTIVITY

The camera provides various connectivity options, including Wi-Fi, Bluetooth, and cable connections, to improve your shooting experience and streamline your workflow.

Here's how you can use these features:

Wi-Fi Connectivity

Setting Up Wi-Fi:

Activate Wi-Fi:

- Access the camera's menu.
- Go to the Network settings.
- Select Wi-Fi Settings and turn on Wi-Fi.

Connect to a Device:

- In the Network menu, choose Send to Smartphone or Ctrl w/ Smartphone.
- Follow the on-screen instructions to link your smartphone or tablet.

Transferring Images via Wi-Fi:

- Download Imaging Edge Mobile App:
- Install the app on your smartphone or tablet (available on iOS and Android).

Pair Your Camera:

- Open the app and follow the pairing instructions, which may include scanning a QR code displayed on your camera.

Transfer Images:

- Select Send to Smartphone on your camera.
- Choose the images you want to transfer.
- Start the transfer from the app.

Remote Control via Wi-Fi:

Enable Remote Control:

- On your camera, navigate to Network and select Ctrl w/ Smartphone.

Connect via App:

- Open the Imaging Edge Mobile app on your smartphone.
- Follow the on-screen instructions to connect to your camera.

Control Camera Remotely:

- Adjust settings, preview shots, and trigger the shutter remotely using the app.

Bluetooth Connectivity

Setting Up Bluetooth:

Enable Bluetooth:

- Access the camera's menu and go to Network.
- Select Bluetooth Settings and enable Bluetooth.

Pair with a Device:

- Select Bluetooth Pairing in the menu.
- Follow the on-screen instructions to pair your camera with your smartphone or tablet.

Cable Connectivity

USB Connectivity:

USB Data Transfer:

- Connect your camera to a computer using a USB-C cable.
- Transfer images and videos directly from your camera to your computer.

Tethered Shooting:

- Use software like Sony's Imaging Edge Desktop to control your camera remotely from a computer.
- This allows you to see a live view, adjust settings, and capture photos directly to your computer.

HDMI Connectivity:

External Monitor or Recorder:

- Use an HDMI cable to connect your camera to an external monitor or recorder.

This provides high-quality video output and monitoring.

CHAPTER TWELVE
EDITING AND POST-PROCESSING

Basic Editing Workflow

Here's a simplified guide to help you start with basic editing for both photos and videos:

Importing Your Files

Photos:

- Connect Your Camera: Use a USB-C cable or a memory card reader to connect your camera to your computer.

- Transfer Files: Copy your RAW or JPEG files to a dedicated folder on your computer.

- Open Editing Software: Import your photos into Adobe Lightroom, Capture One, or Sony Imaging Edge.

Videos:

- Connect and Transfer: Similar to photos, connect your camera and transfer video files to your computer.

- Open Editing Software: Use Adobe Premiere Pro, Final Cut Pro, or DaVinci Resolve for video editing.

- Create a Project: Start a new project and import your video clips.

Organizing Your Files:

Photos:

- Create Catalogs/Folders: Organize photos into catalogs or folders based on your project.
- Rate and Sort: Use ratings, flags, or color labels to sort through your photos and identify the best ones.

Videos:

- Create Bins/Folders: Organize clips into bins or folders based on scenes or types of shots.
- Review and Mark: Watch through footage and mark in and out points to identify usable sections.

Basic Adjustments:

Photos:

- Exposure and White Balance: Adjust exposure and white balance for accurate colors.
- Contrast and Highlights: Tweak contrast, highlights, and shadows to bring out details.
- Color Correction: Use tools like the HSL panel or color wheels to fine-tune colors.
- Crop and Straighten: Improve composition and straighten tilted horizons.

Videos:

- Trim and Sequence: Trim clips to the desired length and arrange them in the timeline.

- Color Correction: Ensure consistent color balance across clips.
- Stabilize: Apply stabilization effects to reduce camera shake.

Enhancing Your Media:

Photos:

- Sharpen and Noise Reduction: Enhance details and reduce noise, especially in low-light shots.
- Vignetting and Effects: Add vignetting or creative effects to enhance the mood.
- Retouching: Use the healing brush or clone stamp to remove blemishes or unwanted objects.

Videos:

- Transitions and Effects: Add transitions and effects to enhance visual appeal.
- Sound Design: Edit audio tracks, add background music, and incorporate sound effects.
- Titles and Graphics: Add titles, captions, and graphics for context and information.

Finalizing Your Edits:

Photos:

- Final Adjustments: Make any final tweaks to exposure, color, or composition.

- Export Settings: Choose export settings based on your intended use (e.g., web, print).
- Export: Save your edited photos in the desired format and resolution.

Videos:

- Final Review: Watch your entire video to check for inconsistencies or errors.
- Export Settings: Choose export settings, such as resolution, frame rate, and file format.
- Export: Render your final video and save it to your desired location.

By following this basic editing workflow, you can effectively enhance and refine your photos and videos captured with the Sony Alpha a7 IV. With practice, you'll become more efficient and develop your own style, resulting in professional-quality content.

Using Sony's Image Editing Software

The Sony Alpha a7 IV captures stunning visuals, but Sony's Imaging Edge software unlocks even more potential. Here's a breakdown of how to use this suite to refine both photos and videos:

Getting Started: Download and Install

- Head to Sony's website: Navigate to the support or download section.
- Download Imaging Edge Desktop: This free suite includes three apps: Viewer, Edit, and Remote.

- Follow the installation instructions for your computer's operating system.

Managing Your Media Library:

Photos:

- Import and Organize: Launch the Viewer app, connect your camera, and import photos. Use folders and collections for easy management. Tagging and rating further streamline your library.

Videos:

- Import and Organize: Similar to photos, import your video files into the Viewer and create folders/collections for better organization.

Basic Photo Editing with Imaging Edge Edit:

- Open Edit: Select a photo from the Viewer and launch Edit.

- Make Basic Adjustments: Correct lighting and color issues with exposure, white balance. Enhance details with contrast and highlights adjustments. Fine-tune colors with color correction tools. Improve composition by cropping and straightening.

- Apply Enhancements: Sharpen details and reduce noise for low-light shots. Use retouching tools to remove imperfections.

Advanced Video Editing with Movie Edit Add-on (Optional):

- Download and Install: Get the Movie Edit add-on from Sony's website for more advanced video editing capabilities.

- Basic Video Editing: Trim clips, arrange them in sequence, and apply color correction for consistency. Utilize stabilization effects if needed.

- Enhance Your Videos: Add transitions and visual effects for a polished look. Edit audio tracks, incorporate background music, and include sound effects.

Remote Shooting and Control with Imaging Edge Remote:

- Connect and Launch: Connect your camera and launch the Remote application.

- Remote Control: Adjust camera settings remotely, view a live feed, and trigger the shutter for flexible shooting options.

- Tethered Shooting: Capture images directly to your computer, review shots in real-time, and adjust settings for a more efficient workflow.

Finalizing and Exporting Your Work:

- Photos: Make final adjustments, choose the appropriate format and resolution (web, print), and export your edited photos to your desired location.

- Videos: Review your video for any issues, select export settings like resolution, frame rate, and file format. Finally, render and save your final video.

You can elevate the photos and videos by mastering Sony's Imaging Edge software. This suite empowers you to organize, edit, remotely control your camera, and produce professional-quality content.

Post-Processing RAW Files

The camera captures incredible detail in RAW format, but unlocking its full potential requires post-processing. Here's a comprehensive guide to achieve professional-quality results using popular editing software:

Importing Your RAW Files:

- Connect and Launch: Establish a connection between your camera and computer (USB-C cable) or use a card reader to import RAW files.

- Software Choice: Popular options include Adobe Lightroom, Capture One, or Sony's Imaging Edge. Choose your preferred software and import your RAW files.

- Organization is Key: Create a designated folder or catalog within your software to keep your RAW files meticulously organized.

Crafting the Foundation: Basic Adjustments:

- Exposure: Ensure your image is neither too dark nor too bright by adjusting the exposure levels.

- Accurate Colors: Correct white balance to achieve natural-looking colors that reflect the lighting conditions in your scene.

- Depth and Detail: Refine the contrast to add depth and dimension to your image.

- Highlight and Shadow Recovery: Recover details lost in highlights or shadows for a balanced and even exposure.

Fine-Tuning for Perfection:

- Clarity and Texture: Enhance midtone contrast and bring out details by carefully adjusting clarity and texture settings.

- Selective Color Control: Adjust vibrance to boost muted colors without affecting already saturated ones. Use saturation sparingly to avoid unnatural color casts.

- Fine-Tuning Tones: Utilize the tone curve to meticulously control the tonal range and contrast throughout your image.

- HSL Magic: HSL adjustments allow you to modify the hue, saturation, and luminance of specific colors, granting precise control over your image's color balance.

Lens Corrections and Transformations:

- Lens Perfection: Apply automatic lens corrections to eliminate distortions, vignetting (darkening of corners), and chromatic aberrations (color fringing).

- Compositional Tweaks: Crop your image to enhance composition and straighten any tilted horizons for a balanced look.

- Perspective Control: Utilize transform tools to correct perspective distortions, ensuring straight lines appear straight in your final image.

Noise Reduction and Sharpening: A Delicate Balance

- Noise Reduction: Especially in high ISO images, reduce noise while preserving details to maintain image quality.

- Sharpening Finesse: Apply sharpening to enhance details, but be cautious not to overdo it, as excessive sharpening can introduce unwanted artifacts.

Retouching for a Polished Look:

- Spot Removal: Eliminate blemishes, dust spots, or distracting objects using the spot removal tool for a clean and polished image.

- Selective Adjustments: Apply graduated filters to adjust exposure and color balance in specific areas of your image, or use radial filters for more localized tweaks.

Creative Exploration:

- Vignetting for Focus: Add a subtle vignette to draw the viewer's eye towards the center of your image.

- Split Toning for Ambiance: Apply split toning to creatively introduce different colors to the highlights and shadows of your image.

- Black & White Conversion: Transform your image to black and white, with the option to further adjust individual color luminance for a unique artistic effect.

Final Touches and Exporting:

- Final Review: Take a final look at your edited image and make any necessary adjustments to ensure you're satisfied with the outcome.

- Export Settings: Choose the appropriate export settings based on your intended use (web, print). Consider exporting in both high-resolution and web-optimized formats for wider sharing possibilities.

Save and Share: Export your final image in your desired format, such as JPEG or TIFF, ready to be shared with the world.

CHAPTER THIRTEEN
MAINTENANCE AND TROUBLESHOOTING

Care and Maintenance

The Sony Alpha a7 IV is a powerful tool, but like any camera, it needs proper care to perform its best. Here's a breakdown of key practices to ensure your camera's longevity and optimal performance:

Cleaning Your Camera Regularly:

- Exterior: Use a soft, dry cloth to gently wipe the camera body. Avoid harsh chemicals or solvents that can damage the finish.

- Lenses: Blow away dust and debris with a blower. For fingerprints or smudges, use a microfiber cloth or lens cleaning tissue in circular motions. Use cleaning solution sparingly, if at all.

- Sensor (Optional): Utilize the camera's built-in sensor cleaning function. If manual cleaning is necessary, invest in a sensor cleaning kit designed specifically for your camera's sensor type. Handle this with extreme care to avoid damage.

Proper Storage Makes a Difference:

- Environment: Store your camera in a cool, dry place to prevent moisture and extreme temperatures that can harm delicate components. Consider using silica gel packets for extra moisture control in humid environments.

- Camera Bag: Invest in a padded camera bag to safeguard your camera from dust, moisture, and bumps during transport.

- Lens and Body Caps: Always use lens caps and the body cap when the camera is not in use. These simple steps protect the lens and sensor from dust and scratches.

Maximize Battery Life:

- Charging: Use the original charger or a compatible one recommended by Sony. Avoid overcharging; remove the battery once it's full.

- Storage: Keep batteries in a cool, dry place. For extended storage, maintain a charge level around 50%.

- Usage: Rotate between multiple batteries to distribute usage evenly and extend their lifespan.

Stay Updated with Firmware:

- Check for Updates: Regularly visit the Sony website to see if firmware updates are available for your camera model.

- Update Process: Follow Sony's instructions to update your camera's firmware. Ensure the battery is fully charged or connect the camera to a power source during the update.

Treat Your Camera with Respect:

- Environmental Awareness: Avoid exposing your camera to extreme temperatures, direct sunlight, or excessive humidity. These conditions can accelerate wear and tear.

- Secure Handling: Use a camera strap to prevent accidental drops. Always handle your camera and lenses with care to avoid physical damage.

- Dust and Moisture Resistance (Optional): While the a7 IV has some dust and moisture resistance, avoid heavy rain or dusty environments. If necessary, use protective covers for additional shielding.

Professional Touch for Long-Term Care:

- Periodic Checkups: Consider having your camera professionally inspected and cleaned periodically, especially if you use it heavily or in challenging environments.

- Repair Services: If your camera encounters issues, seek professional repair services from authorized Sony service centers.

By following these simple care and maintenance practices, you'll ensure your Sony Alpha a7 IV remains in top condition, delivering reliable performance and helping you capture stunning photos for years to come.

Troubleshooting Common Issues

Despite careful handling, you might face some issues with your Sony Alpha a7 IV. Here's a guide to addressing common problems:

Camera Won't Turn On:

Check the Battery:

- Verify that the battery is fully charged.

- If possible, test with a different battery to exclude battery failure.

Ensure Proper Connection:

- Confirm that the battery is correctly inserted and the battery compartment door is fully closed.

Reset the Camera:

- Remove both the battery and memory card.
- Wait a few minutes before reinserting them and trying to turn the camera on again.

Lens Issues:

Lens Not Recognized:

- Detach and reattach the lens to ensure a secure connection.
- Clean the lens contacts with a soft, dry cloth.

Autofocus Problems:

- Switch to manual focus and then back to autofocus.
- Check and adjust autofocus settings in the camera menu.

Lens Error Messages:

- Turn off the camera, remove the lens, clean the contacts, and reattach the lens securely.

Image Quality Problems:

Blurry Photos:

- Verify focus settings and ensure the subject is within focus range.
- Use a faster shutter speed to minimize motion blur.
- Enable image stabilization (IBIS) if shooting handheld.

Exposure Issues:

- Adjust exposure settings like ISO, aperture, and shutter speed.
- Use exposure compensation to correct overexposure or underexposure.

Noise in Photos:

- Lower the ISO setting.
- Improve lighting conditions or use a fast lens with a wide aperture.

Memory Card Issues:

Card Not Recognized:

- Ensure the memory card is compatible with the camera.
- Try reformatting the card within the camera.
- Test with a different memory card.

Slow Performance:

- Use a high-speed memory card recommended by Sony.
- Regularly format the card in the camera to maintain performance.

Connectivity Problems:

Wi-Fi Issues:

- Ensure Wi-Fi is enabled in the camera settings.
- Restart both the camera and the connecting device (e.g., smartphone).
- Check for interference from other wireless devices.

Bluetooth Pairing Issues:

- Confirm Bluetooth is enabled on both the camera and the device.
- Remove any existing pairings and re-pair the devices.

USB Connection Problems:

- Ensure the USB cable is properly connected.
- Try using a different USB cable or port.
- Check the camera's USB settings for the correct connection mode.

Firmware Update Problems:

Failed Update:

- Make sure the battery is fully charged before starting the update.

- Follow the firmware update instructions carefully.

- Retry the update with a different memory card or USB drive if necessary.

Miscellaneous Issues:

Camera Freezes or Lags:

- Turn off the camera and remove the battery for a few minutes.

- Reinsert the battery and turn the camera back on.

- Ensure the camera firmware is up to date.

Error Messages:

- Refer to the camera's user manual for specific error code explanations.

- If the issue persists, perform a factory reset.

Understanding these common issues and their solutions will help you quickly troubleshoot and resolve problems with your Sony Alpha a7 IV.

Regular maintenance, proper settings, and keeping the firmware updated will ensure your camera operates smoothly and reliably.

Resources
Sony Alpha a7 IV website:

- https://electronics.sony.com/imaging/interchangeable-lens-cameras/all-interchangeable-lens-cameras/p/ilce7m4-b

- Sony Alpha a7 IV user manual: https://www.sony.com/electronics/support/e-mount-body-ilce-7-series/ilce-7m4/manuals

- Imaging Edge Software Suite: https://imagingedge.sony.net/l/ie-desktop.html

Official Sony Youtube Channel:

- https://www.youtube.com/user/sony Here you can find video tutorials on how to use the Sony Alpha a7 IV and its features.

- Sony Alpha Universe: https://alphauniverse.com/ This is a website by Sony for creators. Here you can find inspiration and tips for using your Sony camera.

Reviews and Comparisons:

- DP Review: https://www.dpreview.com/reviews/sony-a7-iv-review - In-depth review with image samples, lab tests, and comparisons to other cameras.

- TechRadar: https://www.techradar.com/reviews/sony-a7-iv - User-friendly review with key features, pros and cons, and buying advice.

- The Photography Enthusiast: https://thephotographyenthusiast.com/category/reviews/ - Review by a photographer, focusing on real-world usage and image quality.

YouTube Channels:

- Alpha Gear: [invalid URL removed] - Reviews, tutorials, and long-term tests of Sony cameras by professional photographers.

- Dustin Abbott: https://www.youtube.com/c/DustinAbbottTWI - Experienced photographer who uses Sony cameras, offering tips and tricks.

Forums and Communities:

- Sony Alpha Forum: https://www.sonyalphaforum.com/forum/9-general-discussions-about-sony-alpha/ - Large community dedicated to Sony Alpha cameras, with forums specifically for the a7 IV.

- Fred Miranda: https://www.fredmiranda.com/forum/board/56/ - Active photography forum with discussions on the a7 IV, including sample galleries and user experiences.

Learning Resources:

- KelbyOne: https://kelbyone.com/ - Offers online courses on photography, including some specific to Sony cameras.

- CreativeLive: https://www.creativelive.com/ - Another platform with online photography courses, potentially including lessons on the a7 IV.

- Sony Imaging Tutorials: [invalid URL removed] - Tutorials from Sony on using specific features of the a7 IV.

Accessories:

- B&H Photo: https://www.bhphotovideo.com/ - Large online retailer offering a wide variety of camera accessories, including lenses, filters, tripods, and bags compatible with the a7 IV.

- Adorama: https://www.adorama.com/ - Another major camera retailer with a vast selection of accessories to enhance your a7 IV experience.

Remember, these are just a few examples, and there are many other resources available online and in print.

CHAPTER FOURTEEN
APPENDICES

Technical Specifications

Here are the technical specifications for the Sony Alpha a7 IV:

Image Sensor:

- Sensor Type: 35mm full-frame Exmor R CMOS sensor
- Effective Pixels (approx.): 33.0 million
- Total Pixels (approx.): 34.1 million

Image Processing:

- BIONZ XR Image Processing Engine

Lens Mount:

- Sony E-mount

Autofocus:

- 759-point phase-detection AF system with 94% frame coverage
- Real-time Eye AF for humans, animals, and birds

Image Stabilization:

- 5-axis in-body image stabilization (IBIS) system

Metering:

- 1200-zone evaluative metering with multi-pattern, center-weighted, spot metering

Viewfinder:

- 3.68 million-dot OLED electronic viewfinder (EVF)
- 0.78x magnification
- 120 fps refresh rate

Rear LCD Screen:

- 3.00-inch fully articulated touchscreen LCD
- 1.03 million dots resolution

Video Recording:

- 4K (3840 x 2160) video recording at up to 60p (10-bit 4:2:2 internal recording)
- Full HD (1920 x 1080) video recording at up to 120p (10-bit 4:2:2 internal recording)
- S-Log3 gamma for increased dynamic range

Connectivity:

- Wi-Fi (802.11ac)
- Bluetooth
- USB Type-C port
- HDMI port
- Microphone input
- Headphone jack

Storage:

- Dual SD card slots (compatible with UHS-II cards)

Battery:

- NP-FZ100 lithium-ion battery
- CIPA-rated battery life: Up to 580 shots (viewfinder) / 610 shots (LCD)

Physical:

- Dimensions (W x H x D): Approx. 128.9 x 97.4 x 81.3 mm (5.1 x 3.8 x 3.2 in)
- Weight: Approx. 657 g (1.45 lb) (body only)

Other Features:

- Dust and moisture resistance
- Interval shooting
- Silent shooting mode
- Creative Style and Picture Effect modes

Glossary of Terms

Full-Frame Sensor: A 35mm equivalent sensor that captures more light and detail than smaller sensors.

Megapixels (MP): Determines image resolution and detail level. Higher MP count allows for larger prints and cropping without losing quality.

CMOS Sensor: Commonly used in digital cameras, known for excellent low-light performance.

Image Processing Engine: Converts raw data from the sensor into a final image, affecting noise reduction, color accuracy, and detail.

E-Mount: Sony Alpha cameras use this mount, compatible with a wide range of Sony lenses.

Phase-Detection AF: A fast and precise autofocus system that detects phase differences in light rays.

Eye AF: Focuses on a subject's eyes, ideal for portraits and animal photography.

In-Body Image Stabilization: Reduces blur from camera shake, especially at slower shutter speeds.

Metering: Measures light to determine the correct exposure.

Evaluative Metering: Analyzes the entire scene to set exposure.

Center-Weighted Metering: Prioritizes the center of the frame for exposure.

Spot Metering: Measures light from a small area of the frame.

Electronic Viewfinder: Provides a digital preview of the scene with applied settings.

Magnification: Ratio of the viewfinder image size to the actual scene.

Refresh Rate: Number of updates per second, with higher rates offering smoother viewing.

Touchscreen LCD: Interactive screen for easy menu navigation and image selection.

Resolution: Determines the sharpness and clarity of the displayed image.

4K Resolution: Ultra-high-definition video with four times the detail of Full HD.

Frame Rate (fps): Frames per second, with higher rates providing smoother playback.

Bit Depth: Number of bits per color value, with higher depth allowing more accurate color and smoother gradations.

S-Log3 Gamma: Flat picture profile capturing a wider dynamic range for better post-processing flexibility.

Wi-Fi: Wireless image transfer and remote control.

Bluetooth: Low-power connection for image sharing and remote triggering.

USB Type-C: Port for charging, data transfer, and connecting external devices.

HDMI: Connects the camera to an external monitor or TV.

SD Card: Removable storage for photos and videos.

UHS-II: High-speed SD card standard for faster data transfer.

Battery

CIPA-Rated Battery Life: Estimated number of shots per charge based on standardized tests.

Interval Shooting: Captures photos at set intervals for time-lapse videos.

Silent Shooting Mode: Minimal noise from the shutter.

Creative Style and Picture Effect Modes: Presets that alter color profiles and effects for different looks and feels.

THANK YOU FOR READING

www.ingramcontent.com/pod-product-compliance
Lightning Source LLC
Chambersburg PA
CBHW082235220526
45479CB00005B/1237